Teaching Painting
in the Primary School

Keith Gentle

with illustrations from the work of
Anne Mazza and Sandra Slack

CASSELL

Cassell

Villiers House 387 Park Avenue South
41/47 Strand New York
London WC2N 5JE NY 10016–8810

First published 1993

British Library Cataloguing-in-Publication Data
A catalogue record for this book is available from the British Library.

Library of Congress Cataloging-in-Publication Data
Applied for.

ISBN 0-304-32564-3 (hardback)
 0-304-32566-X (paperback)

Typeset by Colset Private Limited, Singapore
Printed and bound in Great Britain by
Dotesios Ltd, Trowbridge

To TRICIA

Contents

Foreword

The books in this series stem from the conviction that all those who are concerned with education should have a deep interest in the nature of children's learning. Teaching and policy decisions ultimately depend on an understanding of individual personalities accumulated through experience, observation and research. Too often in recent years decisions on the management of education have had little to do with the realities of children's lives, and too often the interest shown in the performance of teachers, or in the content of the curriculum, has not been balanced by an interest in how children respond to either. The books in this series are based on the conviction that children are not fundamentally different from adults, and that we understand ourselves better by our insight into the nature of children.

The books are designed to appeal to *all* those who are interested in education and take it as axiomatic that anyone concerned with human nature, culture or the future of civilization is interested in education; in the individual process of learning, as well as what can be done to help it. While each book draws on recent findings in research, and is aware of the latest developments in policy, each is written in a style that is clear, readable and free from the jargon that has undermined much scholarly writing, especially in such a relatively new field of study.

Although the audience to be addressed includes all those concerned with education, the most important section of the audience is made up of professional teachers, the teachers who continue to learn and grow and who need both support and stimulation. Teachers are very busy people, whose energies are taken up in coping with difficult circumstances. They deserve material that is stimulating, useful and free of jargon and that is in tune with the practical realities of classrooms.

Each book is based on the principle that the study of education is a discipline in its own right. There was a time when the study of the principles of learning and the individual's response to his or her environment was a collection of parts of other disciplines – history, philosophy, linguistics, sociology and psychology. That time is assumed to be over and the books address those who are interested in the study of children and how they respond to their environment. Each book is written both to enlighten the reader and to offer practical help to develop understanding. They therefore not only contain accounts of what we understand about children, but also illuminate

these accounts by a series of examples, based on observation of practice. These examples are designed not as a series of rigid steps to be followed, but to show the realities on which the insights are based.

Most people, even educational researchers, agree that research on children's learning has been most disappointing, even when it has not been completely missing. Apart from the general lack of a 'scholarly' educational tradition, the inadequacies of such study come about because of the fear of approaching such a complex area as children's inner lives. Instead of answering curiosity with observation, much educational research has attempted to reduce the problem to simplistic solutions, by isolating a particular hypothesis and trying to prove it, or by trying to focus on what is easy and 'empirical'. These books try to clarify the real complexities of the problem, and are willing to be speculative. The real disappointment with educational research, however, is that it is very rarely read or used. The people most at home with children are often unaware that helpful insights can be offered to them. The study of children and the understanding that comes from self-knowledge are too important to be left in obscurity. In the broad sense real 'research' is carried out by all those engaged in the task of teaching or bringing up children.

All the books share a conviction that the inner worlds of children repay close attention, and that their subsequent behaviour and attitudes are strongly affected by the early years. The books also share the conviction that children's natures are not markedly different from those of adults, even if they are more honest about themselves. The process of learning is reviewed as the individual's close and idiosyncratic involvement in events, rather than the passive reception of, and processing of, information.

Cedric Cullingford

Acknowledgements

The ideas contained in this book have grown and been enriched over the years through my encounters with many sensitive, thoughtful and hard-working teachers: we worked and shared together and learned from each other, recognizing each other's commitment.

I would like to thank my wife Tricia, whose unfailing support, perceptive reading and timely discussion have helped to see this project through.

It was always a pleasure to visit Mount Carmel Infant School and Mount Carmel Junior School, where Anne and Sandra worked.

I am grateful to Naomi Roth, who has shown confidence and trust in the potential of this book.

Introduction

Children enjoy colour; some positively revel in it. Colour is around us all the time and can affect our moods, our spirit and our actions. Colour matters to us and it matters a lot to children.

Enjoying colour in the form of paint is an important source of pleasure and satisfaction for most children and this experience has long been recognized by teachers and parents. It would be strange to find a primary school that did not provide opportunities for children to handle paint and enjoy the pleasures and sensations of painting.

Teaching Painting in the Primary School is all about how to provide this experience for children of all ages; what to look for in the materials and equipment and how to help children get the most from handling paint.

Many adults who want children to experience painting, whether they are teachers or parents, do come across difficulties. These include the choice and presentation of paints, ways to organize the material and what to look for in stimulating children's ideas. Knowing what to say, when faced with the results of a painting session, can also present problems. This book considers all these issues and many more.

A starting point for the purpose of this book might well be the kind of difficulties which teachers and parents, if the latter allow their children to paint at home, may have experienced themselves particularly when they face the task of helping children. Failures and anxieties that they themselves may have experienced can haunt their present response to the painting children do.

We should ask ourselves 'Where does one start when helping children to enjoy painting? What problems might arise?'

The value adults place on the activity of painting is markedly different from that of children. Young children enjoy painting for its own sake, for the pleasurable sensations it affords. Adults tend to look mostly at the results.

The apparent quietness and contentment of children left to their own painting can be very deceptive. If adults tend to dismiss or overlook such activity, the activity itself can become inconsequential, frustrating and repetitive. In order to build up children's confidence in handling paint the adult (teacher or parent) needs to recognize what kind of experience children are having. The disparity between what children experience and what adults assume is happening creates difficulties in the way children's painting develops. Adults and children need to find real ways of sharing.

1

Further difficulties arise because teachers who don't use the exploratory approach to painting tend to be more concerned about the results of the painting session – how attractive the paintings look to them – rather than seeing ways of sharing the processes of learning that the children have gone through in producing them. They can seem little concerned as to whether any learning about paint has taken place at all.

The enthusiastic and spontaneous enjoyment of painting by 5- and 6-year-olds is exciting to see but can soon disappear as the children approach 7. At this time an anxiety about 'correctness' and 'good' drawing creeps in, revealing a developing lack of confidence. The comments of other children begin to matter and a collective 'view' of 'good' art or 'right and wrong' activity, or of pieces of which the teacher approves, can emerge. Children will begin to question their ability to draw, make demands on their teachers, copy each other or stereotypes, and generally seem more intent on finishing than anything else. The teacher's approval of the painting or agreement to abandon it seem paramount.

Children become aware of and find it difficult to accept their own limitations and to cope with this crisis. This evaporation of confidence in handling paint to convey their ideas and observations is something this book addresses.

The approach which many teachers use of seeking finished results merely accentuates this problem as teachers and children can both feel the pressure to produce attractive paintings, that is paintings the teacher finds attractive. Unfortunately, the teacher's view of attractive art often demands the use of skills and an understanding of paint which the children may not have had the chance to develop.

Learning to paint can be paralleled with learning to read and write: there is a language of marks, shapes and patterns to be acquired in order to develop the powers of expression. Children have to learn how to handle paint as much as they learn how to handle words.

It is the contention of this book that, however interesting the stimulus or the experience to be painted, unless children are educated in mark making with paint, they will always be prey to frustration and loss of confidence. Furthermore, infant children have much greater powers of observation and expression than the easy dismissal of their painting usually supposes. There is a stereotype which supposes that infants always paint in broad, clumsy brush strokes and in gaudy colours.

This book explores the validity of an approach to teaching art based on the ideas which I put forward in *Children and Art Teaching* (Gentle, 1985). The ideas have been put into practice in the teaching of Anne Mazza and Sandra Slack. These two teachers, the former working with infants and the latter working in an adjacent junior school, had developed the ideas in their own ways in their particular schools.

The chapter on painting in *Children and Art Teaching* stimulated Anne to see a possible approach to helping infant children overcome their lack of confidence and extend the range of their painting. In that book there were clear ideas about how the teacher might think about children's learning and through this the kind of painting they did. She recognized that the approach to painting in the book reflected an approach to teaching familiar to most primary teachers in some other areas of the curriculum. Chapter 2 explores this relationship to suggest how teachers might start painting with infants.

As a principle, both Anne and Sandra recognized that if children have not explored powder paint, and observed its special qualities and possibilities, they will not possess the visual vocabulary of coloured marks or the basic sensory experience required to develop and extend their painting.

A number of germinal ideas were shared in discussion and in practice, both in the classroom and on residential and sessional courses. Central to these ideas was the need for children to explore paint and find their own level of skill and control in doing so. Two important conditions attended such exploration: first, the need for teachers to select and present materials with care and understanding; secondly, for them to evolve, with the children, ways of talking about the experience children were having. Experimenting was seen as a natural development from exploratory experience and it was realized that both are as essential to painting as the stimulus of looking and the production of completed pictures. Exploratory activity was seen as continuing alongside picture making and a necessary adjunct to it.

It is believed that the approach to painting described in this book applies to other creative work and also to other aspects of the curriculum. Anne and Sandra have demonstrated in their teaching, for example, that the same approach applies to work in language, science and technology.

Teachers and parents who have not explored powder paint for themselves or encouraged children to do so are amazed how readily children take to exploring it. Many children will talk as they enjoy the sensations paint offers. One has to be aware of the many children who enjoy 'tactile' experiences and who seem to enjoy most getting their fingers into the paint, so be prepared for this eventuality. Children readily discover the characteristics and endless possibilities of paint when exploring it. Adults need to trust children to mix their own colours, and should listen, observe and learn with the children as they look at and talk about their results. The book shows how this can be achieved.

The book will be of interest to primary teachers but also, in terms of its approach to children's learning, to teachers of older pupils. It will be useful to parents too, giving them ideas about materials and how to handle them, and will suggest ways of looking at and talking about what children produce.

The comments about and descriptions of teaching offer something to students and potential teachers and their lecturers.

Chapter 1 is an enthusiastic recital of the qualities and possibilities of powder paint: what it is like, how it behaves, and so on. The next chapter is about working with children of different ages and the kind of learning for which one is looking, and gives ideas and examples of how one might approach teaching drawn from the work of Anne and Sandra. Chapter 3 illustrates some of the children's painting; how they have discovered, enjoyed and mastered paint. It shows examples of explorations and experiments, where these have led, how they have been developed and used and how they have been displayed in school and classroom.

It is not just providing materials and space that stimulates children to paint with enthusiasm and success. Teachers need to be more connected with what children observe, think, feel and want to achieve. Chapter 4 considers how one might use ideas and stimuli to enrich and extend children's painting, for example through the range and use of stimuli, the work of artists and other ways of going beyond the ordinary, the stereotyped and the teacher-directed.

Chapter 5 is concerned with the role of the teacher, how this might be thought about in terms of children's creative responses and the active learning which is integral to it. It is suggested that teaching is a dynamic process, the advantages of which are explored and described. Examples are offered of such a teaching approach in practice.

The recommendations and approach of the National Curriculum are considered in Chapter 6 with thoughts about the impact on primary schools. A number of major concerns for teaching are identified and explored using painting to relate to the main thrust of the proposals. Chapter 7 considers classrooms as places where painting might be stimulated and carried on: it deals with the organization of spaces, storage of materials and equipment; display of stimuli, work in progress and completed pieces. It suggests how teachers can make the best use of whatever space they have.

Chapter 8 looks at the issues surrounding assessment and makes detailed suggestions concerning how this topic could be approached and the value of making the attempt. It is proposed that assessment can function in very positive ways to support teaching and improve the work children do.

The book is designed to excite teachers and encourage them to provide opportunities for children to paint and to give them greater understanding with which to share and enjoy children's painting. It is hoped that teachers will glean some knowledge and develop the confidence to enable their pupils to get the most from the magic that paint has to offer.

CHAPTER 1

Why Powder Paint?

Some thoughts and observations on its characteristics and use

Powder colour is a versatile, comparatively inexpensive, and easy-to-use paint and the one found most commonly in primary schools. Among all the pigments on the market in a similar quality and price range, powder colour is the only one supplied without a binding agent, which extends its shelf life and potential uses.

The range of available paints falls into various categories depending on the medium with which they are mixed and the form in which they are presented. The only general paint source to be marketed in powder form is powder colour which comes in cardboard or plastic cartons or tubs. It is not ready mixed with a medium but is water-soluble. Powder colour can be mixed with other binders such as gum, adhesive or oil but it is not finely ground and remains somewhat gritty and coarse. Other paints (pigments) are marketed with the binder or medium already in them, such as oil, acrylic or gum. However, the most suitable and inexpensive paint medium for work with children is powder colour, so this book concentrates on exploring ideas for using powder colour with children.

QUALITY AND CONSISTENCY

Not all powder colour is of the same quality or consistency and a number of features need to be considered here.

The colour quality itself can vary enormously. If a blue of the same name is compared across the products of different manufacturers it will soon be seen that there can be considerable variations in the quality of the colour. In some cases different batches of the same colour marketed by one manufacturer will vary, so that the blue will shift towards grey or green or purple.

Consistency of colour quality according to its description is essential.

TESTING FOR QUALITY

The nature of the pigment itself can change according to how finely it is ground and whether there is any 'filling' in it. Some powder colours seem cheap but on use appear 'chalky' or are 'muddy' when colours are mixed

5

together. This is because the pigment is not pure and has been extended in some way so that apparent cheapness for quantity is lost by inconsistency and weakness in quality. Poor characteristics such as these can seriously affect the quality of children's painting and to avoid them *it is necessary, from time to time, to test samples of powder colours from different manufacturers.*

BRILLIANCE AND COVERING POWER

The brilliance and covering power of the paint can vary due to inferior pigment or additions to it. Thin, watery mixtures of colour on white paper will reveal certain characteristics, for the pigment should retain much of its colour quality whether mixed thickly or spread thinly. The transparency of paint is one of its most exciting features and should not be lost because of using inferior pigment.

It is necessary to try out the whole range of possibilities a paint offers.

POWDER COLOUR: A BASIC STATE OF PIGMENT

Powder colour, by its nature, can be awkward to dispense. The manufacturers have been slow to understand the problems of handling plastic containers and tightly stuck down cardboard boxes for class teachers. Powder can spread in various ways: by being blown or wafted, picked up on other materials (cuffs for example), and through spillage.

When spilt powder colour comes into contact with water it seems to exaggerate its presence; where there was apparently a little dust there appear great smears of colour when it is in contact with a wet cloth or other wet source. An efficient method for dispensing powder colour in a quantity and into a container appropriate for use by children needs to accompany its use and this will be dealt with more specifically later on in the book.

How powder colour is dispensed for children to use requires careful consideration.

These thoughts lead us to suggest some characteristics of powder colour, other than relative cheapness per quantity, which are interesting and important for an understanding and enjoyment of painting. Colour as powder provides a unique and necessary way of coming to understand colouring materials. The experience of handling colour as powder is the nearest that children can get to the original notion of starting with ground earth or mineral colour with which a medium has to be mixed to make one's own paint before use. This would have been the traditional way of starting in an artist's studio.

When one starts with powder the nature of the material is there to feel, to experience by touch and to rub on to the paper. Mixtures, densities, directions and patterns can all be evolved from simply fingering the paint

on paper. Powder colour on black paper is a different experience from colour on white or toned paper.

It is important to think through the way in which any experience with dry colour is set up. Sheets of newspaper, small pieces of paper to work on, aprons or old shirts to protect clothes and cuffs rolled up are a start. Then a waste bin into which to shake surplus powder and a dust-pan and brush are a good idea.

PRACTICE WITH CHILDREN

Most paints start off as finely ground powder and, in this basic form, powder colour can be used with children. It is best, however, to introduce children to a restricted number of colours when using it in this form, for example, any two from red, yellow and blue.

Teachers can start with some basic questions to themselves, perhaps later to be posed to the children. As far as possible any questions should be open-ended and seriously intended to raise observations from the children.

> What can you do with paint in its dry state?
> What will happen to the paint when you touch it?

Initially, teachers may find it difficult to think of or pose the right kinds of question or the children may be confused and unresponsive. It is most worthwhile to persist in trying to find a starting question or observation; one which 'demands' a response from the children. Once this response occurs, it can be built on and this new 'asking questions – seeking answers' approach can soon catch on. An explanation of this approach is considered further in Chapter 4.

Children could be encouraged to experience the paint in its dry state. Together with their teacher they will need to consider how they will get the paint from the pot to the paper.

> Will they sprinkle the powder on to the paper?
> Will the colours mix and blend?
> Will different tools be used?

The children will be asked to say what they discover about the paint in its powdery state. A number of questions might help them to do this.

> What does the paint feel like?
> Can you find a word for how it feels?
> Does it feel like anything else that you have handled?

At some stage white powder paint could be introduced and the children could be asked to say what happens then. Many colours can be made from

7

the three basic colours red, yellow and blue plus white, and further questions can be raised by this new experience. For example,

> Does white change the way the colours look?
> What can you say about the way the colours change?

Throughout the experience of handling the powdery paint children should be encouraged to verbalize their experience. Paint in its dry state has different qualities and is able to behave differently (do different tasks) than in any of the other forms it might have. It can be sprinkled and rubbed in and other substances can be added to it.

As will be seen from later chapters, much of the work of painting requires simple precautions and preparation as well as the instilling of good working habits. These, after all, are essential to any good classroom practice and forms of learning in which the individual child is to be given some autonomy in his/her own learning and responsibility for the way the working environment is maintained.

Handling materials and apparatus

Handling the materials and apparatus of their learning is a simple, direct and expedient way in which children, of any age, can be offered responsibilities and given trust through which they can grow in confidence generally and in understanding how to manage their own learning. The handling of powder paint is a case, *par excellence*, for the inculcation of such responsibilities and should not be subverted or exchanged for the use of ready-mixed or mixed-ready pots of gaudy paint. The path to understanding and individual mastery is through personal experience which, in the early stages especially, should be prepared and set out carefully, studiously observed by the teacher, and shared between children and teacher with enjoyment; but more of this later.

Having a little courage and foresight in the way powder colour is presented to children can reap enormous benefits in the way children handle paint with confidence and control.

Having thought through how best to store and present powder colour and inducted children into the easiest and most efficient methods for setting it out, handling it and putting it away, it then becomes possible to enjoy paint and recognize the qualities it has to offer.

The characteristics of different kinds of paint

THE RANGE OF PAINT

The characteristics of different kinds of paint can be discerned from using them or watching them being used, or by looking closely at the results of their

handling. To discover the properties and qualities of a medium it is best to explore it through controlled, organized or considered play. Such play does not impose directions, methods or solutions on the medium before it has been openly experienced for what it is. However, each discovery can shape or order subsequent play so that play experience leads to more refined, understood and careful handling. Such changes in the pattern of play can be observed in the behaviour of the individual and the quality of the results.

For example, the mixture of water with powder colour can extend the range of the paint enormously but the way in which this is done requires thought and care. A small piece of rag or paper towel, on which to blot surplus water from a loaded brush, avoids the pots of powder colour becoming hardened with drips and therefore unmanageable.

When the water is mixed with the powder on a small tray, the ease with which it is mixed or otherwise reveals something of the characteristics of the paint. Some powdered colours seem to mix more easily than others, some requiring persistence and care to 'get them started'.

Applying wet paint to a surface depends on how absorbent the surface is. Obviously, blotting paper will cause the water to be drawn out of the pigment quickly and effect rapid drying, whereas a glossy paper will resist water and the paint can only dry through evaporation. There are grades of paper with different qualities of absorption and this is another factor worth noting when making choices.

The position and tilt of the paper, whether on an easel, board or table top, can influence the behaviour of the paint, and once the paint is applied to a surface it behaves in various ways which show up the characteristics of the materials and the colour.

PRACTICE WITH CHILDREN

Powder colour when it is mixed with water presents the teacher and children with new opportunities and challenges. How will the children mix the paint? They could be told how to do this or the teacher could demonstrate the approach which is considered best. There may be occasions when these two ways of handling this situation could avoid undue frustration, but perhaps a more enlightened approach would be for the teacher to encourage children to find their own ways of adding water.

For this to happen, certain ideas, limitations or questions could be posed to get the children to understand some of the problems involved and through this to approach the exploration of the materials sensitively.

Getting children to use a limited number of colours could raise different problems. Questions could be asked such as:

How watery can you make the paint?

How many colours can you make from a limited number of colours?

In what ways can you see different colours mixing?

At certain stages of the children's exploration the teacher could call the group together so that together they could look at the work and discuss their discoveries and what they have noticed.

When you use water with paint it responds in a very different way than in its dry state. For example, children will notice and tell you how colours run into each other; how they can be spread using brushes, sticks and other implements. Some of the observations (tasks) might seem very obvious, perhaps so much so that they might be overlooked, yet they are all part of the exploration stage, which is too important to be missed out.

As has been suggested, paint and colour behave and look differently depending on the type of paper used and whether it is wet or dry. The way in which the paint is handled, how it is used and how it is put on the surface alter its appearance and produce different effects.

The discovery of the versatility and possibilities of powder paint gives children an intelligence and understanding about what this kind of paint can do.

What characteristics might one become aware of through handling or looking at paint? There are a number of these, which will now be described in more detail.

COVERING POWER

A good mixture of paint can cover a large area quickly and if it is mixed with a lot of water it can increase its covering power rapidly, even to the point of running out of control. Paint can be swept on with a large brush, dabbed on with a sponge or cloth, spread with a palette knife or piece of card or run across surfaces. Paint sticks, runs, glides, spreads, trickles, layers and changes; very young children soon learn this and respond to the experience variously. Running paint can be exciting or alarming, fascinating or frustrating, but handling paint is never dull and certainly a lively and dynamic experience. Wet paint spreads into other spaces and other colours as it covers the paper and can shift and change shape and colour as it does so.

PAINT HAS SUBSTANCE AND BODY

Powder colour can be thick and stiff if little water is added or more and more powder is added to a mixing. Stiff and sticky paint has its own pleasures and a loaded brushful applied to paper has its own special pleasures and

satisfactions. One can feel it going on, sense it sticking and smudging; see the thickness glistening and the fullness of the colour reflecting back.

Thick paint worked across a damp or wet surface responds differently to thick paint on a dry surface. It is possible to scratch and draw into the body of thick, damp paint and to work on top of it when it dries. Thick paint can be given particular textures and reflective qualities by the way it is applied and through the addition of other substances.

PAINT HAS FLUIDITY

Colours can be made to run with the addition of water or by working them on to a damp or wet surface. If the paper is tilted, smooth washes of colour can be applied into which other colours can be introduced. The running and spreading of wet paint can be controlled by changing the tilt, level and direction of the surface on which it is applied. As colours run they can be moved about by the fingers, brushes, pieces of card, a palette knife, sponges and so on. Wet, fluid colours run into each other and intermix, creating a multiplicity of hues and shades (light and dark ranges of the same colour and mixtures of colour). The ease with which paint runs can be affected by the absorbency or otherwise of the paper on which it is painted.

PAINT HAS OPACITY AND TRANSPARENCY

The full, resplendent richness of paint as colour must be its supreme pleasure. The intensity or delicacy of colour, its special nuances and accents come about through the quality of the pigment but also through the way it is applied to a surface and the type of surface used. It is the reflective characteristic of a pigment that opaquely beams back to the viewer all the range and depth of its colour. When colours are placed next to each other they affect the way we see and receive them. There can be a vibration of colours when placed next to each other or in particular associations. Being able to build up surfaces is a special feature that paint possesses; as paint dries layer after layer can be applied and this is to exploit the opaque characteristic of the material.

The opposite quality to opacity is transparency and paint has this quality also. This is the capacity to create delicate washes of thin colour through which other colours or surfaces can be seen. Subtleties of colour, in softness and change, can readily be seen when working on white paper or white card. To develop this approach to the full damp paper has to be stuck down to a board by using brown sticky paper round the edges. This 'stretching' of the paper enables the surface to be worked on without it rucking up, so that many layers of colour can be applied to the surface, as can be seen in watercolour paintings.

PAINT HAS TEXTURE

Texture is to do with surfaces, with how something feels to the touch. Roughness and smoothness, in all kinds of variations, can be achieved with paint, through variations in its appearance or application. Thick mixtures of paint can be applied differently to a surface: by stippling and dabbing, spreading and scraping, using different tools and adding other substances to them.

The way brush marks are assembled on a surface can suggest texture and also the manner in which colours and surfaces are built up or worked into each other. There are those individuals who revel in the tactile nature of paint and some children seem to derive their satisfaction from just mixing and mixing and seldom 'making a picture' of anything other than paint.

PAINT HAS COLOUR QUALITY AND VIBRANCY

The choice of colours to fill a palette is critical. Each colour has its own peculiarities and ways of behaving. Certain colours mix well together and provide a wide range of good secondary and tertiary colours; others seem to have a limited and limiting effect. Powder colour has nothing like the individuality and range of, say, oil colour. Nevertheless, it is well worth taking trouble to select the most suitable and balanced palette of colours and limited additions that one can.

Small paint containers seem to come in sixes; although this is handy it can be restricting. Black and white seem essential but could be provided in larger, separate containers. The primary colours are also essential: red, blue and yellow. Two reds might be offered, one tending towards purples (cerise) and one towards oranges (vermilion). Two yellows might also be offered, such as a lemon or a mid-yellow, and ochre to give rich, earthy colours. The blue might be ultramarine, which is a medium colour enabling good greens and purples, leaving one space for, perhaps, a brown like burnt umber.

Once a palette is selected it should be kept so that children begin to know and understand the nature and behaviour of each colour, just like old friends. Children will learn the richness and mixing capacity, the covering power and intensity of each colour, bringing each one into the harmonies and contrasts that suit their purposes and moods. They will find out how colours vibrate and 'sing' together; how they create their own feelings and enable feelings to be created.

Of all the things that paint has to offer, surely colour must be the most exciting and rewarding for children to discover and use.

PRACTICE WITH CHILDREN: CHILDREN DISCOVERING PAINT

It is through the exploration of paint that children will begin to discover some of the variations of quality and behaviour which have been described. Such exploratory activity gives children the opportunity, in a relaxed yet purposeful manner, to find out about the nature and possibilities of the medium, paint. Children need to have experiences at their own level if their understanding and confidence are to grow. The results may not always be predicted by the teacher in the same way as when they try to direct children's activity but can follow certain observed patterns.

The more that teachers find ways of sharing what children do, through their observations, questions and conversation, the more these patterns of behaviour will be seen and understood. Children may discover many things about paint when they explore it as a material and it is their increased awareness of paint, achieved in this way, which leads to their having confidence in using it.

Children discover different ways of controlling paint by exploring. They realize that there are different ways of making and arranging coloured marks, such as lines, shapes and patches of colour: they will see that different surfaces, textures and tones are made. They might make ordered arrangements from the coloured marks or explore the intermixing of surfaces and colour. Whatever they do, the sensation of paint can be very pleasurable and rewarding in itself as well as enabling children to find new techniques, practise new skills and achieve different levels of control.

Discoveries made in this personal way promote a sensitive use of paint. This can be seen in how children dilute and mix colour; in how they apply it and devise the right technique for the right effect. Some techniques will be acquired accidentally in the process of exploring, but if at a later date they are able to use these skills and techniques, then it can be seen that learning and understanding have taken place.

The next chapter suggests ways in which painting with children might be approached.

CHAPTER 2
Approaching Painting with Young Children

This chapter considers how a teacher or parent might begin painting with young children so that the children gain confidence and achieve some independence in the activity.

What is required? The early contact with paint for young children needs to be one of pleasure. This may arise from the way the paint feels and behaves when touched with the fingers or a brush; or it may be to do with colours that excite interest and pleasure. Under the wrong conditions painting can become a frustrating experience. The whole approach should be one of finding out, not one of following directions and filling in given shapes.

If an exploratory session with paint is to be a positive and satisfying experience for young children, the teacher must give some thought to preparing the working area and providing children with the most appropriate materials – paints, brushes, paper – in terms of quality and size, and working surfaces. It makes an enormous difference to the success of a painting session if there has been careful selection, preparation and setting out of materials to be used. Once this preparation is done, arranging and setting painting things out need not become an onerous task for the teacher. Children enjoy sharing in this work and taking on the simple responsibilities it entails, and in this shared preparation the standards for the care of materials and their use can be established.

A little forethought in how a painting session is to be managed pays enormous dividends.

It is very much easier and more effective, initially at least, to limit the range of materials and keep the approach simple. It is easier to move towards a wider range of colours and painting materials once the children are taking some responsibility for the materials used and working with the classroom routines the teacher has established.

A simple and well-managed approach to painting enables children to learn the rudiments of paint handling and colour mixing easily and, from these, to invent, adapt and explore their own ideas and ways of doing things. One real, personal discovery is worth much more than all the taught techniques and teacher-directed methods. Children can be helped to adapt and refine their discoveries because through these they can see the need for such development. To instruct children in how to mix or use paint before they have any personal experience of it is to inhibit their discoveries and undermine their confidence.

14

However, acquiring personal experience of something as volatile as powder paint can be a frustrating and unnerving business for adult and child unless it is well managed.

Anne recalls many occasions when infants could be observed trying unsuccessfully to control long, runny drips of paint travelling irresistibly down the vertical surface of paper attached to an easel. The paint they had been given was too watery and could not be controlled by the one available brush, which was far too thick for the task in hand. She reflects that there must be many infants who cannot understand why mummy's eyes on their picture almost fill the total face area and, in some cases, run into the body. This is simply because it is impossible for them to control the paint with a large brush when it is presented to them in a watery, lumpy condition.

The paint should be presented in small quantities in containers that cannot be knocked over easily. If, initially, a teacher feels more confident in presenting pre-mixed paint, a few colours only should be prepared and be of an even, creamy consistency. It is my view, however, that young children should be introduced to paint in its powder form, and then be helped to mix the powder with water. Some may respond naturally to such mixing while others may need more 'hand-holding' in order to get started, but in the long run the effort to work with them at this stage pays dividends.

Working on small pieces of paper resting on large sheets of newspaper, children can soon discover ways of mixing once the idea catches on. Possibly the major problem is getting powder to paper, when spillage might occur, but with sensible precautions this will not be a disaster. Fine brushes as well as large ones, small spoons and spatulas can help.

The teacher needs to keep an eye on how children are managing and even be in close attendance for the first exploratory sessions until confidence and good patterns of working are established. The sense of enjoyment in mixing and putting paint on paper can be intense, especially if the early steps are handled carefully.

Time spent in watching what happens and listening and talking about the way children do things, sorting out snags and difficulties as necessary, enables the teacher to establish good habits and attitudes to work.

It is inaccurate to suppose that infants naturally paint in a thick, clumsy manner when it could well be the result of the materials with which they are presented. Using poor and inadequate materials usually results in frustration and disappointment. It also endorses feelings of frustration and inadequacy if the teacher responds to a child's work by saying only 'That's nice; if you've finished put it over there', when really the child needs help and understanding. This book seeks to promote a more informed and purposeful relationship between children's creative endeavours and their teachers.

Rarely are infants trusted to mix their own colours and rarely are they given a choice of brushes, yet it is this simple expedient that could reduce frustration and change dramatically the quality of the images they produce. It is not just a matter of teacher or parent allowing them to do this, but of seeing that it is really necessary and that planning, preparing and then working with children until they confidently master the first steps of handling paint is essential. One has to start with the belief that infant children can be trusted to handle clean, dry powder paint and small brushes.

Powder paint should be dispensed so that it is managed easily by infants and they are given a realistic opportunity to mix their own colours.

Only through the direct, sensory experiences of exploring paint and making their own discoveries can children develop an intelligence about paint. Only through having the opportunity to use a variety of brushes can children develop sensitive handling of the medium. It is vital that teachers recognize these prerequisites to learning, which make children's exploration of paint purposeful.

In addition to the careful organization of the materials, the encouragement and active interest of teacher or parent leads to the qualities and possibilities discovered while handling paint being given value. Otherwise, the very experiences from which children's understanding grows might be overlooked or discarded. Adults' active interest in what children do enables them to find ways of looking at and discussing their discoveries and avoids them making preconceived judgements.

The understanding that older children bring to painting can build on such early experience but, as we shall see, older children also need to continue exploring the material in their own way.

Everyone will find their own solution to the problems of managing powder colour so that it can be handled with ease by young children. It has been found, for example, that some container tops (approximately two inches in diameter and one and a half inches deep) make suitable receptacles for dry paint and they can be stored in discarded plastic food boxes. They hold more paint and are less fiddly to handle than the commercially produced trays of six pots. This method enables the amount of colour to be controlled and separate colours to be renewed easily. Clearly, one of the first jobs to be thought about is how to provide children with small amounts of powder colour and the means to mix it.

At first, limiting the choice of colours to, say, the three primaries encourages children to mix their own colours. In powder colours the primaries would have to include two reds, one crimson (for mixing purples) and the other vermilion (for mixing oranges). This small range of colours can produce a great range of variations but only if they are handled with care and patience. Once a technique for mixing and intermixing has been

evolved, the inventiveness and pleasure which most children reveal for mixing is considerable. Later, as their experience increases, they can be helped to discover that small additions of black or white will not change a colour type but increase its range.

A suitable palette of colours might consist of two reds (one vermilion and one crimson), a yellow, a blue, a black and white. Limiting the range of colours in this way will promote a great deal of colour mixing through which children, even very young children, will grow in understanding and confidence.

The kinds of discovery which might be made by children when they explore paint will be discussed in detail later, but Plates 1, 2, 13 and 14 give an indication of the range. One purpose of encouraging children to talk about personal discoveries is to help them develop a visual language.

The development of visual language

In discussing the development of children's visual language, it is useful to consider the parallel with verbal language. In the latter, children are given plenty of experiences of hearing and seeing words and using them in spoken and visual form as a way of developing verbal language skills. Even where children experience limited language at home they nevertheless absorb words and phrases, intonations and usage from television, radio, comics, books, and adults other than parents. There are many language materials available to teachers to increase and enhance the range of children's spoken and written language when they come to school. Where it is hoped more personal expression will arise, teachers give children a rich experience with words before they expect them to write poetry or construct prose.

By contrast, children are seldom helped to build up a parallel visual vocabulary of colour mixing and coloured marks before they are expected to produce 'a painting' ('a symphony of coloured marks at its best', as Anne says). Where children build up such a vocabulary and are actually encouraged to do so, they will begin to look at and talk differently about their surroundings. Furthermore, the shared endeavour of a teacher with a group will increase the language with which the teacher and children talk about paint and painting.

The comment and exchange between teacher and children will grow beyond the trite explanation, the adult-imposed descriptive label or the dismissive aside. Children are often asked for an explanation of their 'picture', and if this is not forthcoming, a descriptive label is imposed on it by the adult. This approach too often inhibits the child rather than opening up their looking when there is plenty to talk about in most children's paintings. For example, notice the consistency of the paint. How was it achieved? Can they show you? What about the direction, vigour or delicacy,

rhythm or repetition of the marks or brush strokes? There is much to be enjoyed here and to be shared. Other examples are described elsewhere. Simple conversations can lead to all sorts of developments.

Finding words to talk about painting can help both teachers and pupils to understand more.

It is surely not surprising that young children who have not had the benefit of an exploratory experience with paint produce the same kind of stereotyped images whatever the stimulus, and this situation is often maintained by the unthinking comments of adults.

Children who have not explored powder paint are not equipped to solve the practical and aesthetic problems involved in producing a painting. It is self-evident that they need to develop the skills of mixing and handling paint, and of arranging the shapes, colours, lines and textures which arise from these experiences, before and alongside the making of paintings. This is especially true of children of junior age (8 to 11 years old) who are developing far more pretensions about the things they want to paint, as will be discussed later.

The more positive and satisfying the early experiences of handling paint are, the more likely children are to build up a visual vocabulary. It is this developing interest in the way things look and how paint behaves which gives them the confidence to communicate their ideas visually. Learning how to communicate ideas and experiences through paint is not and should not be a random experience acquired by chance but one that is helped to mature by the observations, questions and shared enjoyment of the teacher.

I believe that it is as much the responsibility of teachers to accompany or follow painting sessions by some discussion and sharing of an experience as it is to provide materials. Discussion is an important way in which children's sensitivity to the medium and the images it makes is heightened. Talk about what they do helps to develop an 'intelligence' about painting and looking at things in a painterly way. To take just one example, they will learn from their discoveries, both in looking at painterly things and in handling paint, the difference between thin and thick paint and when it is more appropriate to create a thin, transparent wash or thick, lumpy impasto for the effect they want to achieve.

Problems that arise and thoughts about a solution

As mentioned earlier, children enjoy painting for its own sake, but unfortunately, because of this, some teachers use painting as a time-filling activity, something to keep children occupied whilst they get on with what they consider to be a more important activity, such as working with language or mathematics.

What is more commonly found in infant schools is that children can choose to paint at an easel for part of the day as a sort of relaxation or as a reward for finishing set work. In these circumstances the teacher may occasionally ask a child to talk about his or her painting, to say what it is about or perhaps what they like. There is little, if any, discussion about the experience of painting, the qualities and possibilities they found with the paint, or anything else that may have been discovered. So, there is little chance of development beyond a set of casual, subjective opinions and the repetition of previous approaches, whether judged successful or not.

Apart from the lack of communication about their experience of paint, infant children are too often given poor materials with which to paint, for example, thick, round brushes and four or five containers of ready-mixed paint whatever the subject they have chosen. Furthermore, because the paint is ready mixed, it is often too runny, too thick or too garish in colour for the children's particular purpose. Junior-aged children often fare little better, being offered only large brushes and a varying assortment of colours such as several different makes of blue and oddments like purple. To understand how colours behave, a palette of colours should be decided on and kept as standard. This simple procedure is likely to help children to come to know, respect and understand the specific merits of a given colour range.

Before Anne started to use the exploratory approach to painting she tended to be more concerned about the results of the painting session than the actual experiences children were having; she was concerned with how attractive the paintings looked, rather than the process of learning which the children had gone through in producing them. She hadn't thought to question whether there had been any real learning about paint at all.

She found that the younger children, 5- and 6-year-olds, painted enthusiastically whatever the stimulus, and even without one. However, she noticed that children of 7 plus were beginning to feel ill equipped to cope with the challenges set. At the beginning of each session the same children would say, 'I can't draw . . . I'm not good at art. Will you start me off? Can I draw instead? When I've done this can I do my own painting?' or, after a few minutes, they would call out, 'Finished!'

Anne recognized that the children always enjoyed the build-up to a piece of painting, that is, the looking and touching and talking about the stimulus, but never seemed to want to get started with the actual painting. There seemed to be no comparison between the bubbling enthusiasm with which the children explored the stimulus and the painting sessions that took place afterwards. It seemed they were becoming aware of their own limitations and found it difficult to accept them.

The approach Anne was using to cope with this situation, she felt, merely accentuated the problem. Together with the children, she felt the pressure

to produce attractive paintings using a visual language of coloured marks which the children had not had the chance to develop in their own way. She felt that this was like expecting children to play a tune on a piano without them understanding or even knowing about the notes. With the introduction of each stimulus, little progress seemed to be made in terms of raising children's sensibility to the qualities and possibilities of paint.

After reading a chapter entitled 'A possible approach to teaching art' in *Children and Art Teaching* (Gentle, 1985) Anne felt she had found a possible answer. The approach to painting described in the book reflected an approach to teaching which she recognized as being familiar to most primary teachers in another context. Teachers adopt an exploratory approach to writing, physical education, mathematics and science with young children, so why not with painting? For example, before children write a piece of poetry or prose, interesting words and ideas are explored and their particular qualities discussed; and after a writing session good examples are shared and described with the group or class to increase their awareness of what is possible.

Or again, she recognized that in the physical education lesson children are encouraged to respond in different ways to physical challenges, for example finding different ways of travelling by taking their weight on two parts of the body. The teacher observes the particular qualities of movement in what each child does and brings these out through comment and discussion with the group as an integral part of the learning that is going on. By observing and discussing the movements of individual children or groups of children who have responded well to a challenge, all the children are made aware of other possibilities.

Why shouldn't young children enjoy exploring the particular qualities of paint for their own sake and share the way they tackle this with other children? Observations and ideas about paint qualities and what they might represent can extend children's looking and enlarge their paint-handling repertoire.

Anne thought that this approach was the right way to go about art teaching too. She had always looked for interesting stimuli, objects, plants and people, animals or events, and expected the children to paint them, but had not stimulated children to handle paint for its own sake. She now saw that if children have not explored powder paint as a material and discovered its special qualities and possibilities, they will not possess an understanding of the visual vocabulary of coloured marks which is required to control paint to make pictures.

Sandra also found this approach necessary when working with junior children and now always gets children to spend time exploring the medium or talking about how something they are observing might be interpreted in terms of the discoveries they have made with paint. She has extended

the exploratory discussion of ideas and approaches into other areas of the curriculum such as science, language and technology.

CHILDREN FIND THEIR OWN LEVEL

Children find their own degree of practice when they explore paint, and by giving some time to observing them at work the teacher is able to see how their practice grows. Some children require a great many exploratory sessions to discover just a few of the qualities and possibilities of paint, whilst others will have discovered some of these already for themselves at home or in the nursery and need added stimulus fairly quickly if they are to progress. The added stimulus may not be a teacher-directed one, or a representational one, but could arise from sharing what other children are doing; from looking at the colours, textures, surfaces and arrangements of objects or from extending the paint handling in some new direction. This is how experiment, trying things out, can develop from exploration and making discoveries.

Experiments, trying to repeat or develop something that has been found out, even by accident, follow naturally from earlier explorations.

The time a teacher gives to observing children painting is better than time expended in demonstrations of how to paint, which children are expected to follow. Through their observations, teachers will see which children need to be given opportunities to develop practice further and which require more time to explore and experiment along the lines they have already adopted.

Often the experiments of junior children will result in new ways of handling paint and, through these, new ways of looking. The illustrations of autumn colour and texture show how explorations with paint shaped the way the children looked rather than the looking changing the painting. The thick, impasto paint of autumn trees makes one look again at piles of leaves mulching the ground (see Plate 10).

There is no reason why a child whose efforts need stretching in some way should not be able to paint from a natural form or plant in the same session as others who are experimenting with coloured marks only. The teacher has to help children to see that one type of experience (experimenting with paint) is no better or worse than another (exploring tree shapes in paint), but just different: children can then see the relevance of both experiences. The kinds of comment made by the children about paint experiments can also apply to their paintings, which are first of all paintings using the visual referent, trees.

Experimentation is a vital part of the art-making process and something which artists continue to value long after they have produced their first

21

'work of art'. 'I don't work by any rules, things work as you go along. It's a case of experimenting to see what will happen,' Robin Philipson said of his approach in a BBC film about painting.

It is important, therefore, that children do not suddenly stop exploring a material for its own sake or experimenting with the discoveries made once they begin to work from a stimulus; the two experiences go hand in hand: exploration spawns experiment, the experiments help them to look differently, and their looking adds to the experiments.

Exploration is a continuing and integral part of learning about paint and painting.

Although teachers' expectations and pupil responses will vary, depending on the age of the children, an exploratory approach can be adopted with any age group. It is even the best approach to adopt with adults handling paint for the first time. In order to paint well, children and adults need to understand the nature of the material they are using and discover different ways of handling it as a *substance*, as a *colouring agent* and as a *material for mark making or drawing in colour*. Teachers and parents who have not explored powder paint for themselves, or encouraged children to do so, are amazed how readily and easily children discover and enjoy the characteristics and endless possibilities of a material like paint once they are given the confidence and opportunity to do so. All they need to do, after presenting the materials well, is trust children to mix their own colours and listen, observe and learn with the children as they look at and talk about the results.

Very rarely are there discipline problems during an exploratory session with paint, although by their nature such sessions have to be relatively free if children are to grow in the confidence of their own discoveries. Children are usually too enthralled by what is happening to mess about and their conversations are usually about the ideas and excitement stimulated by their paintings, which they naturally want to share.

Not only do some children make personal discoveries which influence others in the group but they can initiate whole new ways of looking and working. Management of the group and control over how the experiences are given value and direction come about where the teacher encourages the 'currency' of looking at and sharing ideas and discoveries. If left alone, many children can feel a loss of impetus and direction. It is the teacher's skill at sensing the time to share observations, their own and the children's, and drawing out the value of the discoveries made, which underpins the value of the experience to the group and confirms what they have learned.

There is always something worth talking about and sharing in painting, from which others can learn.

Getting started

How might the infant teacher get started? It seems a good idea to organize children into groups of ten or less for several short exploratory sessions followed by time for observation and some conversations about the results, rather than one long session with the whole class which provides little opportunity for any conversational looking and exchange.

Having decided on this approach it is necessary to give children clean, dry powder paint in small containers, water, a selection of different-sized brushes, a mixing tray (not essential at first), small pieces of black, white and grey paper, clean newspaper and clean rags. The paper is small in order to keep the exploration short, manageable and therefore less intimidating; and of three shades (black, white and grey) so that the children are able to observe the different effects produced by powder paint when it is used on a light, a medium and a dark background. A similar range would be a good start for junior-aged children (see Plate 1).

It is not advisable to give infants a mixing tray at first because they have a tendency to paint the entire tray with one colour and see little point in transferring this to the paper. Furthermore, the trays have to be washed before they can be used again, and this is disruptive and wastes time. Initially it is far better to let children apply the paint straight on to the paper and see how it flows and mixes under these direct conditions.

If infant children are to be trusted to use good brushes of various thicknesses, shapes and sizes, they also need to be trained in how to handle them with care. They need to be constantly reminded not to leave the brushes standing in water as this increases the risk of water spillage and therefore more disruption, and can also ruin the bristles.

Clean rags are also essential, because the powder paint in the pots must be kept as dry as possible. There is nothing worse than finding lumps of hard paint in the powder. In fact, I would go as far as to say that discipline in regard to handling the powder paint is the single most important factor that will affect the confidence of teachers to adopt an exploratory approach with their children. If poor management of the paint makes the cleaning up and refilling task too great and too time consuming, many teachers will not bother to try the approach a second time.

CHILDREN SHOULD BE DISCIPLINED IN HOW THEY HANDLE PAINT

Teachers have been heard to say that infants make too much mess when they are allowed to mix their own colours. This is not necessarily true. Infants will make a 'mess' with paint or any other material if they are not helped to understand why making a mess is bad practice and then shown carefully better ways of managing it.

It may be argued that infants are not able to explore the paint freely if they have to worry about the condition of the paint pots they are using. It is argued here that, because they are shown and understand how to look after paint, their painting and paint management improve.

Children will and must take responsibility for some care of the materials they are using, whatever their age. The alternative is for the teacher to spend at least an hour at the sink after each session, emptying, cleaning and refilling pots which are unfit for further use. This kind of labour is the point at which many teachers abandon the exploratory approach as impracticable. If infants cannot clean and refill the pots themselves without incurring more work for the teacher, they can learn to handle the paint with care and sensitivity which then only requires pots to be replenished. Juniors can certainly take on and manage such responsibilities.

Anne admits that, in order for children to really experience paint, she allows them to make quite 'a mess' the first time they explore powder paint but after this initial free experience she insists that they keep the paint pots clean and dry. She feels, strongly, that it is better to be firm about the way children look after the materials for practical purposes than to be firm and restrictive about the way they paint (the images and marks they make). Even young children can be helped to appreciate that they are only free to paint as they wish if the paints from the previous session are clean and dry.

It follows from these observations that it is better to have several short, purposeful sessions with a group of about ten children, ending when attention wanes, than one long painting session with the whole class. Such a scheme enables each session to be followed by some observation and discussion; working with the full class, which is less manageable, can easily become purposeless, with many children demanding the teacher's attention.

What has been described so far is a way in which every painting session can be introduced with short, exploratory sessions prior to the main painting activity. These short sessions both renew children's discoveries and the language evolved to describe them, and tune them into handling the material with care and sensitivity.

Third short session: more control of the paint

The first one or two exploratory sessions during a period of painting really need to be followed through immediately with a longer session. This 'third' session provides more scope and opportunity for children to develop what they have found out and invent variations on the themes they have discovered.

The children often produce more 'ordered' results in the third session because of the increased confidence and understanding about paint which has been acquired. Not only do they discover how to control the paint in

various ways (tilting, mixing and so on) but they also begin to organize the marks into patterns or some kind of picture instead of making patches of colour at random all over the paper (see Plates 13 and 14).

The children are encouraged to be as inventive as possible, mixing new colours, using paint of various thicknesses and generally thinking of different ways to apply the paint and organize their shapes, lines and so on.

Rather than making pictures as such *they are mark making in colour.*

HOW MIGHT ONE LOOK AT SUCH PAINTING

Looking at what is produced as marks of colour is one way to enable both teacher and children to take a wide view of the results. Every child will have some success and something to contribute when their painting is looked at from this point of view. The quality of control seen in the marks that are made and the relative thickness or density of the paint are points of development that can be achieved by every child. The range of colours mixed and their juxtaposition on the paper; the ordering, grouping and patterning of the colours and the marks are other examples of what can be looked for and discussed.

Children begin to control the paint and organize the coloured marks in various ways which an observant teacher can see. Anne noticed that in this kind of session the children tended not to do a lot of colour mixing, and thought that perhaps this was because they were concentrating more on the type of marks they made and how they organized them than the range of new colours they might have made.

The following are the kinds of result which have been seen as arising in this third session, and some are shown in Plates 1, 2, 13 and 14:

- the use of strong, vibrant, contrasting colours side by side with hard edges;
- pale, delicate, watery shades from the same colour family which blend together or leave blurred edges;
- wide areas of thick or thin paint which make shapes or delicate washes;
- sprinkled dry paint on to wet paint;
- one layer of thick paint built on top of another as part of their design;
- single, short brush strokes or dots to form a pattern or design;
- long or short lines which may be thick, thin, curved, straight, applied with a quick/slow wrist movement, striped or trickly (produced by tilting the paper) and so on, to make some kind of pattern, design or picture;
- printed, textural effects to create a design.

The textured effects may have been produced in various ways:

- with the side of a large, flat brush;
- with a piece of paper folded to form a symmetrical pattern;
- with an old rag or sponge;
- with a finger or hand;
- with any tool made available for making interesting marks.

It is important that the teacher discuss with the children what has been happening during these sessions. Such discussion can include how the children have used various ways of controlling the paint and organized the coloured marks, how different shapes and textures have been arrived at or how they have made some kind of pattern or picture. After this third session the children will be more confident and informed, as they will have more of their own experiences of painting about which to talk.

To stimulate more discussion and the sharing of ideas, the work from the three sessions can be displayed with appropriate captions derived from the children's own comments as well as the teacher's, showing and describing what has been discovered. This approach is equally valid for junior children.

It is worth displaying groups of work after discussion with the children. These can reinforce what has been learned and act as a reference point for further work.

As a result of this approach, Anne found that children began to work independently instead of relying on her, the teacher, for ideas all the time. This meant that as their teacher she could spend more time observing, listening, working with individual children or demonstrating techniques at appropriate times and generally getting to understand their art making.

It is from this observational and sharing activity that some knowledge develops of how children work, and the teacher can see how to help them. This also provides the class teacher with the basis for some form of assessment of what children do in art. Anne says that she gained from the experience of talking with children about their art and that she found it easier to assess their progress. She was also better able to look for such things as qualities of perception and imaginative response and see the ways they had overcome difficulties (see Chapter 8, on assessment).

Anne feels that working in this way is obviously right, with painting sessions arranged in three parts aimed at children developing an understanding of painting *through their own practice*. She says that she had usually looked for stimuli in plants, natural forms, interesting objects and so forth as a source for painting, and had not always stimulated children to handle paint for its own sake. It now seemed evident that some visual vocabulary, required to make paintings of real or imagined things, had to have been acquired beforehand. Children need to have explored powder paint and discovered for themselves its own special qualities and possibilities. Further-

more, when they move into the stage of being self-aware and more critical as juniors, an important basis from which to handle their ideas in paint would have been learned.

Developing painting with older children

Many of the things already written about approaching painting with infant children apply when working with junior children. There will be important differences, which will be brought out as the ideas and ways of working are described.

As children move from infancy into childhood, between the ages of 6 and 7, significant changes take place in how they see and respond to the world around them. This is the age of self-awareness; a time when children develop concepts and ideas about aspects of the world independent of any direct experience of them. They will play games to rules or make up rules, accepted by the majority, for the things they want to share. They will have ideas about how things function or fit together: they will experiment and play with ideas. At this time of crucial change in their thinking and understanding, children will carry in their minds concepts about right and wrong; about how correct or incorrect their drawing is; about what makes a good painting or the notion that they are no good at it anyway.

In fact, many children in junior schools have such a bad experience of painting that they feel convinced that they can never be any good at it. Bad experiences of painting often arise because some of the simple organizational things are overlooked or not considered sufficiently important. Clean paint, a means of mixing colour and a way of drying surplus water from the brush and keeping water replenished and clean are some of these. The choice of colours, brushes and papers is also important.

Paint, as a material, has such diverse and varied possibilities that there must be something of interest and satisfaction in its use for most children. However, this will not be the case if the teacher has the view that painting is only about making pictures of things. If this limited view is also corroborated by the collective and hidden opinion of the children themselves it will determine many more failures than successes. Criteria like exact representation, careful delineation and copying will rule if there are no discussions of alternative views.

In this situation many children will lack confidence and sense failure almost before the brush touches paper. The teacher may develop a sense of helplessness and see no way out.

Often, the ways out of this impasse to which teachers resort are to devise 'exercises', craft-type experiences, filling in and copying, or avoiding the handling of paint altogether.

The period of time for children when they become self-aware is difficult to handle in terms of their art, yet crucial to their creative development and fulfilment. The practical experiences of Anne and Sandra evolved a way through this impasse which other teachers may find helpful and on which they can build.

All that has been said so far about getting started with young children applies to older children, bearing in mind the changes in their understanding and thinking. Hence, the junior teacher would still use exploratory sessions with paint but extend them through experiment and invention. Furthermore, discussion about how paint behaved and techniques discovered for handling it would be related, conceptually, to visual ideas, projects and personal looking. Projects would also be discussed in terms of how they could be painted, bearing in mind the paint explorations already completed by the children. The displays of their work on the classroom walls would draw attention to their discoveries and stimulate discussion and speculation. An example of this approach is found in the paintings stimulated by winter, which Sandra's class followed as a topic (see Plates 3 and 4).

A PAINTING SESSION WITH CHILDREN OF JUNIOR AGE

Sandra works with two tables of six children when she approaches painting with a class of thirty-two boys and girls aged 10–11. These tables are sited near the sink for ease of access to water and clearing up. The rest of the class will be working on things at which they are confident and can manage with the minimum intervention of the teacher. Sandra's attention, as the teacher, is with the twelve children who are painting.

The paint is set out in six small plastic pots on a tray, but only certain colours will be put out and others taken away. Perhaps Sandra would put out only one red and leave out the blue and on another occasion put two different reds or two yellows out. Before a session starts she would lay out the tables, or get a few of the children to do so, and maybe put out two or three brushes of different thicknesses.

As the paints are kept in small pots they can easily be changed or replaced, but are always fresh and clean for each new session. The children manage to keep the materials like this because the practical side of caring for the materials is well instilled at the beginning of each session, and especially each term. It is this attitude of expecting care and thought in what is undertaken which influences the attitude children have to their work.

When the children start it is usually with just two colours. For example, if they're going to look at red and yellow, Sandra wants the children to find out how many different colours and different shades they can make. She asks if anybody already knows what will happen? If they say 'Orange',

she asks, 'What kind of orange?' They are then encouraged to experiment to see how many different oranges can be made from the limited colours provided and whether the oranges all look the same when painted on light paper and on grey and if they notice anything special about the differences. The teacher encourages the children to find out as much as they can about the paint: how many different colours can be made and so on.

She tries to get ideas and observations from the children about what they are discovering. For example, she gets them to consider the effect on the paint if they put too much water or too little water with it or what can be noticed if you put the red and the orange next to each other.

Once one of the painting groups has started Sandra might then encourage another group to explore red and yellow. She would be aware that some children find this very hard to do; in one instance this was because too much paint had stuck to the brush. The difficulty some children have in mixing paint is caused by such simple practical problems. Because Sandra was there and saw what was happening she could help them overcome such difficulties, rather than picking them up later when frustration would lead a child to say 'I'm no good at painting'.

Also, by not giving the children an activity where they were just left to get on with it, it was possible to see what they were discovering and ask the group if anyone else had suggestions that might overcome any difficulties encountered.

The teacher should ask children what they notice when they are exploring or why certain problems arise and if there's any way to get out of them. It's necessary to talk about the work in hand so that problems and difficulties can be discussed as they are encountered. To leave children to 'get on' misses the opportunity for the teacher to understand how they learn and also reduces the value of the activity in the eyes of the children.

This kind of session would be for about half an hour or until the children's interest is waning or they need further stimulus. For example, in one session on mixing colour thickly Sandra felt the need to use an outside stimulus, so she got the children to look at the autumn from the classroom windows. She asked them what they noticed about the trees and their colours, and encouraged the children to take a rectangular section of the window as a frame to focus their looking. She challenged them to reproduce just the colours they saw in that rectangle: not the tree, just the colours.

So one way in which this teacher gets her pupils to really concentrate on looking is to get them to put down their paintbrushes and just look. This leads to conversations about what is seen, differences and similarities in colours and textures and how these might be interpreted in the medium of paint. She also had some reproductions of Impressionist paintings of grass, and asked the children to look at these again by blocking off a

..all section of a painting in order to focus their looking on the painterly quality.

Masking, blocking off or in some way limiting the view of what children can see when looking at landscape, objects or the work of artists, focuses their attention on qualities other than descriptive appearances.

In response to her questions about what they saw, they said 'Just a lot of colour'. She then asked them if they could create the same kind of feeling in their pictures of trees by taking just a small section rather than attempting to paint the whole tree.

The teacher must ask a crucial question:

'What do I want them to find out through exploring paint?'

The variety and richness of the answers to this question develop during work with children. One thing the teacher wants them to discover, for example, is what results they will get when they mix different-coloured powder paints. The teacher will know generally the sort of colours they might find but, as each child works in an individual way, they will achieve their own different shades.

What the children discover has to be used in some way and it is for this reason that the teacher uses the focus, in this instance autumn colours. Every child makes some kind of discovery which they can enjoy and put to use, for they are all on the journey of discovery and confidence building, but at different stages.

Everyone will learn some paint-handling skills though they may not all get the same enjoyment from these. The children will produce many examples of mixing paint in a short space of time as a result of their explorations. In order to maximize this kind of experience the children have access to a variety of types of paper in small sheets. At the end of the session Sandra puts all the paint studies together and talks with the children about them.

Again she asks questions of herself:

'What sort of things would one talk about with them?
What would one expect them to notice?'

It is reasonable to expect them to notice the number of different colours; different shades of the same colour; thicknesses and textures of paint. They should realize that if they put orange on a different-coloured paper it produces a different effect; that if they put orange next to a different colour it will alter the power of its colour.

These sorts of thing can be noticed by anyone, especially when they are shown to matter, and children soon develop the confidence to talk about them. This approach to raising children's intelligence about painting

increases confidence and minimizes failure. There is never a hierarchy of better and best; one cannot say that one piece of colour exploration is better than another; they are just different. Working in this way, Sandra reports that none of the children felt the need to draw pictures and everyone found something to give them confidence and enjoyment.

Sometimes she might not spend very much time talking about the work, feeling that it is not a thing one draws out but rather reacts to in different ways with different children. For example, some children might say 'Oh look what's happened to this!' and then one can comment. The teacher should avoid saying what to do next as a prerequisite to talking about it. Discoveries and learning happen naturally.

What helps this approach to be successful is good classroom organization so that the teacher can be with the painters all the time, neither distracted by the rest of the group nor chasing materials that are not to hand.

A general talk or key lesson can be given to the whole class, asking questions of them as a group, such as, what colours do they think are autumn colours? It is important to verbalize with the class what you are actually doing because this gives it another dimension and helps all the children to understand. It also places the activity of the painting group in context so that when other children have their turn they are tuned in to what is expected.

When a teacher knows what he or she wants children to learn, it can be shared when teaching children and the resulting range and variety of interpretations enjoyed.

By the end of the year the children will have had a range of experiences on which they can draw. To produce good paintings and to learn to look with care and discernment, they need to explore the paint first.

Although focused looking helps children to see, the exploring of paint in this way gets the children to see differently.

Sessions like the above can be extended at the time or developed on another occasion. There is always a need to refocus attention on the qualities of the paint; one example of this might be when it is mixed with water. It is easy to get into difficulty when paint is too wet but it is also difficult to mix amounts of thick powder colour.

If the session aims to draw attention to how paint and water react the same restricted palette can be employed. Children will gain a knowledge of what happens when colours are mixed together and a lot or a little water is added. To carry out this exploration with many colours instead of a few would confuse the objective.

Children are helped to experiment by using several small pieces of different papers so that no one piece is overworked and each discovery can stand in its own right. Different wetnesses of paint look very different on black, white or a toned paper. Some paper is absorbent; others resist moisture. Each child can find out how wet paint behaves in their own way and through sharing

discoveries with the group. To encourage an exchange of ideas, Sandra pins up their experiments for all to see.

Simple observations can lead to categorizing and grouping the displayed pieces so that certain points are brought out more strongly. For example, those pieces which have colours mixed through their wetness could be grouped. Other pieces may exhibit other qualities that the children notice: brilliance or softness of colour; the effect of background paper; or the transparent, see-through look that paint can have.

Children should be encouraged to discuss their findings and share their understanding. We do not learn in a vacuum!

A display, captioned in the words the children use, could be made showing what the group have discovered. This would confirm and explain what they had been doing to themselves and to parents and visitors to the school. Such a display could also be a reference for further learning.

A stage will be reached when all the children will have looked at one or two colours in detail; they will have had time to experiment with dry paint, thick paint and watery paint and they will have had opportunities to mix paint. They will have had experience of overlapping colours and trying shades of the same colour on different kinds of paper. Their learning will have been directed in a purposeful way because the teacher will know what skills he or she hopes the children will acquire and how their understanding will develop.

Most importantly, the children will have had an opportunity to report back their findings and to understand some of the qualities of paint in a constructive, learning environment. The basis of the teacher's comments about their painting will cease to be subjective and teacher oriented and be more genuinely one of shared and growing understanding.

This chapter has been about getting started. The means are really simple when one spends a little time considering them. The way of working with children and sharing the experiences they have is essential to the continued growth in confidence of teacher and children alike.

Painting, like any creative activity, is not a random and formless experience which can be left to ferment on its own. The insights, questions and conversations of a caring and observant adult are an essential adjunct to the learning which is opened up through such activity.

CHAPTER 3
Examples of Children's Painting

The following small sample of paintings by children taught by Anne and Sandra will give some idea of the kind of work described in the text. This is only a representative collection, intended to illustrate the approach described in this book.

When looking at these paintings one should seek evidence of children beginning to understand the medium and to use it with confidence. Furthermore, one should sense and perhaps recognize that these children are intelligent in various ways about paint and painting.

For example Plates 1 and 2 show the early explorations of 5–6-year-old children. Notice the changing brilliance of the colours when painted on black paper, particularly the purples. The child could be asked how that colour was found; other children could be asked which colours they liked or how many different yellows they could find or what makes the yellows so different. Answers should not be supplied by the teacher, so that the exchange is kept as open and conversational as possible. Many things will be heard and seen which may not be overtly registered but which will nevertheless influence future paintings.

The wet brush strokes over sprinkled and rubbed powder colour have produced a subtle range of one colour. Children can talk about these effects and will be surprisingly knowledgeable about how they have been achieved after a little experience with paint handling.

It is a worthwhile exercise for teachers to bring together a group of children's paintings to discuss, just to recognize how much is noticed when a group takes a little time to really look together; see for example, the paintings shown in Plates 5 and 6. One could question where the reason or motivation for the paintings started, and amongst a group of staff different people will make suggestions from their different strengths. The detail in the water creatures shows evidence of considerable close looking and acquired knowledge by 6-year-olds, perhaps prompting the view that 'research' from living things came first and this fact heightened the experience.

There must have been a competence with handling powder colour for the wetness not to get out of hand, even when painting wet paint into wet paint. Ways of getting children to converse which open dialogue with them about their work will be suggested as teachers discuss the paintings.

Plates 3 and 4 show the kind of thinking which a teacher puts into children's

learning. One could ask about the reason behind the colour mixing: was it science or art? How much evidence is there of children thinking or visualizing? What kind of conversations or questions would elicit this activity from the children and confirm what is observed? Why have you mixed these colours? would provide an answer but is rather direct. Perhaps a more general conversation about what makes winter so different from other seasons would be managed more naturally by teacher and child.

One might observe the soft changes in the different mixings of crimson, blue and white and raise comments on how much or how little colour is needed to effect such subtle changes and how it is done. There is evidence that the children have experimented with different ways of changing a colour (blue): adding water, adding white or adding black.

How does one get a child of 10 to experiment with colour and texture as preparation for painting an owl? One can see a joy and exuberance in using different brushes to explore feather-type textures (Plate 7). Surely the confidence to use such a sophisticated approach must arise from previous experience upon which the child has built. One could open discussion with the child about this view, not by asking where it was learned but through taking a perceptive interest in the work. For example: How did you start with your experiments? What effects were you looking for? Open questions like these can lead to discussion about the painting from which further insights about the child's approach and understanding could be gained.

Comments about the texture and appearance of the owl could also lead to a conversation from which to appraise what the child has learned and understood. There are many avenues into conversation with an individual child or group, which, once explored, lead to an increase of knowledge and confidence. How should one look at children's paintings (artwork)? What can one say? The objective should be, at first, to encourage and focus the child's looking, thinking and talking, not to tell, instruct or pass opinions. Looking at these illustrations might be a starting point from which to realize how much there is to be discussed.

Extending and Enriching Children's Painting

In a now famous statement Picasso said, 'I do not seek, I find.' In this sense children, like Picasso, find things all the time because so much of their lives and living is an opening up of new experiences for them. Even a walk to school across familiar territory will be different for a child than for an adult. For one thing they're nearer the ground and see things from a different physical viewpoint.

As adults we know too much and see too little! We seldom walk these days, and tend to hurry; even when we have time to notice and take in the things around us, as we might on a relaxed holiday, our minds are busy with many other things.

Children notice things because they still have an insatiable curiosity about them. Even children who might be oppressed by the pressures of city or family life, spending much of their time developing 'streetwise' survival, still have a personal and particular awareness of things in their environment.

We may never know how a child notices colours and shapes, plant growth and types, reflections in windows of sky, footprints in the mud and another hundred and one other curiosities that pass our attention, if we never find ways of communicating about such things with them.

It should not be said that children have no curiosity or ideas because they never seem to show these in school; rather we should ask whether they have been given the confidence and the opportunity to reveal these aspects of their personalities. We all know how differently we respond in different environments; an approach which encourages the sharing of experiences, of observations and reflections, draws these from us. We are both stimulated to talk and shown how to conduct conversations.

If you want children to talk, talk with them; if you want children to develop listening skills, listen to them with the interest and attention you seek in them.

The principle of behaving towards children as you want them to behave is an obvious one and one which has close parallels in how children are encouraged to look with care and discrimination and handle objects and materials with sensitivity.

Given that a classroom is an empty space, in which, more or less, a teacher can provide what he or she wishes in order to make a learning environment, the scope is endless.

There are many examples of teachers changing the appearance and arrangement of their classrooms to give some practical, tangible expression to something being studied. Changes can range from enclosing a small corner for the display of special objects, to using hangings and drapes, screens and sheets of cardboard, and rearranging cupboards and tables to transform the whole working space into a new environment. The impact of such changes, when well managed, can energize children's learning through stimulating talk and conversations, stories and poetry, painting and drawing, investigation and invention.

One particularly interesting example of this kind of transformation has been an island project, where children constructed an island home through their making and inventing, writing and conjecturing. The learning which developed from the island environment included dramatic presentations and stories, scientific experiments and simple technologies, drawing, planning and painting, crafts and so forth.

However, such a dramatic change and use of part of the classroom is unusual and not always necessary in order to extend and enrich children's work. The first concerns should be to give them the chance to see things in their own way and demonstrate the value of their observations. To do this we have to enlarge their view of what is acceptable and what it is possible for them to strive for in their ideas, and then help them realize the high expectations which are encouraged in this way.

If all these concerns sound idealistic, let us see where they start and how they can be developed.

The use of stimuli

The simplest of objects brought into a classroom can have the potential to stimulate children: the most precious and elaborate object, brought into a classroom in the wrong way, can fail to excite them. Children have to be helped to handle objects; to pass them between each other and share them; to find ways of talking about their experience of them and to listen to what others have to say. A brick has as much potential for this as a Ming vase!

What might the potential of a brick be to stimulate ideas and learning? Bricks can be found virtually anywhere. They have many characteristics which are vital to the builder, for example size, shape, hardness and compactness. Why are these important? How many bricks fit together in a given space and what weight are they? How are they made? How many bricks does a man lay in a day and what do we call the man who lays them?

All these and other types of question can come out of discussion with the children and should not come from simply telling them. Why?

The teacher uses a range of knowledge about bricks to encourage the children to do some important things.

The first is to focus, to give attention to the object in a very special way. They have to really *see* and to *sense* the object's, in this case a brick's, size, shape, dimensions, colour, texture and surface and so on, as much as a bricklayer who holds many hundreds of bricks every working day. The children have to focus on the object, and this requires time for them to really experience it, so that they drink in the sensations of it. It is only in this way, and not in the superficial way of answering teacher's questions, that their experience will move to a deeper level. The work on bricks illustrated in Plate 8 shows something of this approach in practice.

Secondly, the experience of a deeper level of knowing about the object can only arise when children are helped to focus. At this deeper level they will begin to *associate* their accumulated personal experience with their experience of the object. Other bits of knowledge, other images and memories, will be drawn into their seeing. It is this building up of associations, analogies, metaphors and images, in the mind and feelings, that promotes ideas and learning from real sources of experience. Real experiences without it can end up being meaningless, frustrating and empty.

Thirdly, children will communicate naturally through gesture, facial expression, words and sounds; they will need to talk and share as they find exciting and unusual thoughts coming into their minds. They may even be surprised (the teacher certainly will be) at what they know, see and understand. The motivation, to know and explain and to question what they don't know, will be strong if not always articulated: they will want to do something more about all this than dismiss it quickly or superficially. They will see the point of recording what they have seen through writing, drawing, painting and so on.

Fourthly, they will want to *act*. Talking about and discussing what they see and feel is one way of clarifying it. Writing and drawing is also a way of clarifying and confirming what has been noticed, however little, and how they have responded, however weakly.

If children have been educated in the means to express ideas and feelings, they will do so with confidence and commitment because they have been given ways of seeing and understanding.

If children have been educated to express themselves through words, then, when they respond to a stimulus, it is through words that they most easily and readily do so. If children have been educated to handle paint they will also be able to both see and respond in terms of paint. To become confident in handling paint is to grow in confidence in seeing things in a painterly way (see Plate 7).

Paint is a marvellous medium for children to interpret what they see

and what they feel. As we have seen, powder paint has all kinds of qualities which can be discovered and put to use if it is approached in a thoughtful and sensitive way. Generally, when children feel confident and happy, they enjoy paint as a material. Once their handling of paint becomes second nature many other things become possible which cannot be appreciated until this is so. Ways of enriching and extending their learning arise because children feel confident with the material they are using, not because the teacher gives them more complicated and clever things to do. Children will find things to paint for themselves.

Seeing things to paint becomes possible because they paint things they see.

The act of handling paint, or sharing with others their handling of paint, with all its possibilities of colour and atmosphere, opens eyes to the painterly qualities that are in the environment, in each person's surroundings. The soft smudging of clouds against a blue sky; the full bunching of greens caught in the light and shade of trees; the changes of orange, brown, red and grey in the slabs of a brick wall; all these are seen differently and in a special way because they are painted; they are not just painted because they are looked at!

The act of painting is itself a way of looking.

We saw new colours in the landscape because the Impressionists painted them; their painting revealed their looking and enabled our looking to be different. To encourage the act of painting is to encourage the experience of looking.

The brick will now become much more interesting, for it has texture and colour, perhaps a name stamped on it which shows up in different light conditions; it has a history and use, which may be in evidence in the neighbourhood; it was made somewhere and transported and someone will have worked with it and know about it in the community. And, of course, bricks are not just one colour but many colours and hues of the same colour and they come in a wide range of colour types. How do bricks get so many colours?

So the questing journey starts! Who knows, once started, where it will end? *En route* there will be talk and conversations, drawings and paintings and many other things, some of which will appear in the programmes of study for the National Curriculum and many of which will be well beyond it.

Once children develop the skills to respond to stimuli and have evolved and practised some techniques to handle a medium, the motivation to work is transformed. We will now consider these two areas in which enrichment and extension can be well practised by teachers: handling stimuli, and evolving skills with paint.

Handling stimuli

To merely dump a stimulus, whatever it might be, in front of children, or just to leave it about, is to miss the importance of how a teacher introduces a stimulus into a room or handles it when it is there. The problems are decreased considerably, and are certainly different, if children are used to looking at and handling stimuli. It seems to me that there is a need to reinforce continually the basic approach to using stimuli with children, not only as part of their learning process but also because each time a teacher works with first-hand experience potentially new things can come from it.

WHERE MIGHT WE START?

Each time of year, each season, each month, has its own special quality. The sombre richness of an autumn morning with a hint of frost in the air, pinching the leaves to turn them brown, red, gold and russet; the haunting call of a robin or the fluttering of starlings like black leaves tossed in the wind; the last flowers of the year turning to seed, pink rosebay willowherb with its wispy white seeds blowing here and there and the hooked seeds of burdock and goosegrass catching in clothes.

Many of these things are found in town, city, village or country.

The feel of the seasons changing and the quality of each day within this broad pattern are something deeply rooted in our history, our natures, our way of life, our festivals and our remembrances. Each season has its quality of light and shade, its colours and textures, from the brittle sparkle of a frosty winter morning, with the ice reflecting and sparkling in the sharp, yellow light, to the soft heaviness of a leafy, ochre summer. These are sensations of colour and mood, place and time. Children feel these things and respond to them.

Do we ever stop and listen to the sounds of the day? Sense the muffled dampness of a wet day or the rushing, creaking buffet of a windy day? Can sounds evoke colours and shapes as they evoke words and phrases? Children can become attuned to atmosphere and circumstance.

All these sensory experiences of being and living are there with us and our children all the time, every day, day after day, as much as we are with them or they are with us. But, like our children, we can pass all this by and register only the immediate, the dramatic, the newsworthy, the unusual, that which gets in the way. We know that our mood affects how we are and what we see and hear; the way we look and enjoy looking; our interest in things around us; our curiosity and the time we give to sharing and discussing.

One could say that, like the children, we allow a lot of life and living to pass us by, unrecorded and therefore unnoticed.

.e experiences we all have are the many things which go
icial appearance or the immediate response. We live in
.mediate, the sensationalized, the headline and the slogan.
.th our children, need to sense the width of connections and
. that hold places, events, people and things together; or the
.t gives things their place, their history and their meaning.

The handling of paint is a paradigm for this and can become a metaphor
for the experiences and feelings of everyday. This is certainly the case when
using paint as the medium of expression. As children come to understand
the qualities of paint, so they will notice paint-like qualities in the things
they encounter.

If children always only draw they are likely to notice only graphic qualities.
In terms of our brick, children who paint regularly and are confident and
intelligent about handling paint will be far more likely to notice blends of
colour, changes in hue and intensity, effects of light on surfaces modifying
the colour and so on, than those who don't. If they only draw they are more
likely to see outlines, marks and tones.

If children are versed in using paint the teacher can talk with them about
the paint qualities of the brick and how they might use paint to describe
or interpret them. Such a conversation would be meaningless if the children
and teacher had not already developed their capacity to enjoy paint and
know what to expect from its characteristics and ways of behaving.

The sources, ideas and inspiration for painting are there 'under our noses'
waiting for us and our children to see. They could be shown them many
times without *seeing* them but, because they begin to paint them, they begin
to see them.

Children can be led into painting which is superficial and immediate in
an effort to 'get things on the wall'. If children's experience of painting is
to be satisfying and enlarge their perceptions of the environment in which
they live, they need time to make connections within their experience of
handling paint, and support to build on the discoveries and experiments
they make. Painting, as a learning experience which helps the processes of
feeling, looking and understanding, needs to spread across the possibilities
it offers, not to be contained in the teacher's view of what should be done.

*Painting needs to become an activity which always offers more because it is being
built on, added to and developed.*

If the stimulus is an object or something which can be held , the manner
in which the teacher presents it to the children is crucial. To hold it and
touch it with care; to place it in the palm instead of gripping it with the
fist; to use fingers to enjoy surfaces and draw attention to smoothness and
roughness; to hold the object in different lights, against the window to throw
up silhouetted shapes or in full light to reveal shadows; or to place it on a

similar or contrasting background to camouflage it or enhance the colour: all these ways focus children's attention on different aspects of the object.

Children can be helped to see things as well as show us things we hadn't noticed or didn't realize in the same way. The heightening of their perceptions is as much through our acknowledging what they see as through our expecting them to accept what we want to show them. For some purposes, using a stimulus as a catalyst between the teacher's educational intentions and the children's understanding and learning requires such direct handling as is described here. At other times, objects may be set out on a windowsill or a cupboard top, on a side table or even on the floor. Vertical and horizontal surfaces can be used, each area offering a different way of displaying and viewing the objects and therefore bringing out different features and properties of the things displayed.

Children don't see and receive the same things from a stimulus as adults; we all see and feel differently and bring different kinds of experience to the act of looking. Even the mood and physical condition of the observer can affect what he or she sees. So teachers should not and really cannot expect children to get from a first-hand experience what they get from it; nor will children have the same experience as each other. There will always be a disjunction between what a teacher hopes children will see and what they actually see.

It is in this very disjunction, between the teacher's experiences and intentions and their children's responses, that the greatest potential for confidence building and development lies. If it is handled badly it erodes confidence and is also the source of apathy.

To supplant children's genuine responses with the teacher's more informed opinion will not, strangely, extend children's learning; it can only extend their information. It is through building on children's own observations and responses that learning is extended as well as developed.

In terms of painting, teachers can enrich children's learning through the way they provide real experiences which evince the properties and possibilities of paint. Children's own experience of painting will enable them to see such experiences in terms of their potential for using the medium.

Evolving skills with paint

The discovery of wet paint – floating, creeping, shifting and staining, running and smudging across a piece of white, toned or black paper – can be magic. The suffusing of a clear blue with a bright yellow – watching what happens when they blend and discovering what happens to wet paint on damp paper, even though it's not representing anything – is magic for most children.

41

way of influencing those around you, so that others want to know, want to share in it.

ιat of the experience of mixing and mixing a colour so that it and juicy, swollen with colour and sticky with pigment? To ϳwϲϲρ ϳuϲɴ a paint mixture across a page, to sense it spreading with a palette knife, a paste spreader or a piece of stiff card is a sensory experience all of its own, whether it represents anything or not.

Painting can be about paint.

Experiments and explorations can be about paint.

Discoveries and developments can be about paint.

What happens when you make your very first orange? Somehow yellow gets warmer and warmer; the colour begins to zing and draw your attention. Somehow, this time, the water and the brush were clean and the colours to mix fresh and clear, and all this came together to make the orange bright and startling. Next to blue or red it seems different. It seems to start from the page, almost to hurt the eyes next to the blue. Next to the red it becomes even hotter.

Things can happen just with colours.

A small dot, circle or stroke of orange placed on top of another colour, just enough and not too much, can make all the other colours change; it holds the eye, becomes more significant and demanding than its size suggests. Colours can alter the appearance of shapes and make things appear different.

There's so much to enjoy about paint just as paint, whether we represent anything or not. Do children always have to make pictures of something? So often paintings don't start by being anything except paint. Discoveries found through handling paint as colour, texture, shape and size can be the beginning of a whole lot of looking. The memory and imagination can be stirred by paint as paint; its colours can recall things we've seen and experienced, remind us of things we may have forgotten or dismissed.

Paint, itself, can be the most important stimulus to painting.

If painting leads us to look in a painterly way, we can also be led to paint what we see. It seems to be true that handling paint for its own sake stirs the imagination to see pictures in the patterns and colours that are made. This is only one starting point for 'picture' making; there are others, among which the stimulus of real things should be highlighted.

Sandra found that some experimentation with colour mixing and methods for making textures was a good lead into making a painting from life. Looking at an object or environment suggested the types of colour and texture to make, and the experiments with the medium developed the concept of the painting. The painting of the barn owl (Plate 7) illustrates this point clearly. The paintings of winter show a similar approach in which the children experimented with making cold colours as a lead into the winter paintings (Plates 3 and 4).

Simple, small-scale paintings as ways of exploring the visual appearance of something and finding approximations in paint can become an expected and looked-for part of the preparation for making a painting. These experiments can be shown to the whole class and form part of the discussion about the painting as well as being part of any display or exhibition.

Experiments confirm and extend what an individual has discovered.

Experimenting with paint as a means for interpreting looking is an obvious development from the paint explorations and both are significant in developing an intelligence about paint and painting, appearance and interpretation.

Painting can start with very simple ideas rendered in painterly terms but derived from looking. Once the first statement has been made, the painting can take on its own momentum and direction, using the observed world as a referent only rather than something to be copied. For example, the thick texture of mixed browns and oranges which can be seen in the autumn paintings of Sandra's pupils (Plate 10) could be derived from looking at tree bark. As the paint is applied, worked over, scratched into and built up, the paint itself will change the nature of the looking, returning the artist to see other features in the object previously missed. The leaves and foliage might be seen in terms of thick blobs and strokes of paint rather than as individual leaves. The autumn paintings have this quality about them, interpreting autumn more richly than may have been strictly observed but making us look at and feel differently about the autumn we see.

The way stimuli are shown to children and handled with them can excite ideas about how they might be painted, leading to experiments in colour and texture. This approach could become as much a recognized route to making a painting as setting out the paints, brushes and paper. Once the idea takes hold that paint is used to interpret what is seen more than just to copy it, the possibilities for painting are endless: once it is realized that statements in paint can evoke imaginatively the world of real things, the capacity to see pictures everywhere will increase.

Painting is not merely a way to record what is seen but a way of revealing a rich world of things unseen.

A teacher's task in extending and enriching children's painting is helped first and foremost by having an open, enquiring and perceptive approach. To look at children's paintings with a mind full of stereotypes and preconceptions is to encourage the repetition of tried and dull formulas. Having an open, enquiring approach leads to becoming more informed and perceptive about children's painting, and about how to teach it.

CHAPTER 5
The Role and Approach of the Teacher

Central to children's experience of learning are teachers. Teachers exert considerable influence through their personalities over all the areas of learning which come readily to mind. The particular way teachers use their authority, their confidence to handle different kinds of communication, their capacity to build effective working relationships and their ability to organize and manage the learning environment, all have considerable influence over how children learn.

In areas of learning such as English and mathematics there are established texts and materials from which teachers usually work. They organize, interpret, plan, present and assess how children learn using such prepared materials. The manner of children's learning and the patterns of behaviour which become associated with that learning also derive largely from the teachers' handling of these materials.

Related closely to the teaching from prepared materials, the organization, expectations and authority of the teacher are important in matters of daily routine, which establishes periods of settled individual learning balanced by group work, by class projects and activities, or by teacher-led or directed work. All these things establish a climate of learning. At the start of the school year with a different class of children, or during the year at the start of each new term, experienced teachers consciously set the standards of behaviour, organization, verbal and visual exchange; all those things which establish the climate for learning.

What children grow to expect from their teachers and the teachers expect from their pupils forms a balanced, secure and working climate; one which is most easily ordered and controlled when all the participants know what they should do, feel they can in some measure do it and have a sense of participation and achievement.

There are two considerations about learning which disturb the realization of this apparently settled arrangement. First, we have all come to accept that learning takes place not through rote, simple repetition and recall, but through the active participation of the learner in the process of learning. Even when the learners do not appear to be active, the approach by teachers and the demands of prepared and commercial materials from which they are expected to work aim to stimulate responsive, active, participatory learning. Teachers look for and assess the effectiveness of their endeavours,

and the teaching materials they use, in the responses and behaviour of the children.

Learning is, therefore, encouraged and expected to be active. In this light, different types of movement, sound and activity are integral to the learning which is taking place. Conversational exchanges, questions and comments, collecting and returning items, borrowing and sharing materials, making and using space to work, collaborating and so forth are all necessary for active learning; but all these features of active learning can also be possible sources of disturbance. The acceptance of levels of noise and movement is different in different people, but noise and movement can disturb the confidence of some teachers. As we shall see, it is important to distinguish between the levels, sources and functions of sound and movement in a class if teachers are to manage well creative work and especially activities like painting.

It is from this pattern of active learning that the busyness and movement of primary classrooms grow. Witnessed by others outside the role and responsibilities of the teacher, it can appear confusing, even disorganized. For the teachers, this pattern of activity is demanding and finely tuned between supported, managed, learning and individual patterns of work; it shifts continuously in what is asked of their observation and response. Into this arena of activity teachers build patterns of stimulus and direction, checks and balances, moments of individual and collective sharing and reflection, as well as periods of sustained individual, group or class work.

It is within whatever working arrangements teachers create that the second consideration about learning finds its place; that is, the creative and imaginative parts of children's education. Starting and continuing with play and exploratory experience, the awareness of the need for imagination in learning is there in all of us. It seems that imagination enables us to make connections, see possibilities, devise solutions, invent ideas and evolve patterns. It is not just in the creative arts that imagination plays such an important role in learning, but it is in the arts that it is so central and manifest. In the arts, it appears, there are no answers to guide the teacher; no texts to work from and no right or wrong solutions. Prepared materials from which to work, such as those found in magazine and television articles, seem to force teachers into a position where their role remains one of giving directions or providing more 'things to do'. Ready-made art teaching seems to stimulate children into expecting novelty and perpetuates the need for more ready-made art teaching!

If the teachers' role is central to all other aspects of children's learning, then it is so for learning in the arts. In the arts, however, children have varying degrees of autonomy over what is done and make many of their own decisions about the work they do. The directive approach, which

45

g from set schemes and books and is used successfully
children's learning, can trap the same teachers into
ecting children's creative work. Even though teachers
ecting children's creativity and doubt the results, where
at direction it can be very difficult to break the pattern.

I encountered of a teacher inappropriately directing
children's painting was in a large junior school where there were two parallel
fourth-year classes. The two class teachers had agreed that one would take
art with both classes while the other took the physical education sessions.
The reason for this arrangement was that one of them felt at a loss in directing
the art of his class. His approach in directing all other aspects of their
curriculum was, he felt, satisfactory. In 'teaching' them painting, however,
he felt totally inadequate and had reduced his pupils' experience to one of
drawing round templates of animals and filling the results in with
ready-mixed bright colours. He could conceive of teaching art only in the
way he taught other subjects, as setting work to be done; yet he recognized
how inadequate this solution was.

In order to explore the issues this raises for teaching art I will use the
example of teaching painting; the principles which emerge are applicable
to the teaching of art, craft and design.

A central purpose of this book is to suggest ways round the syndrome
of giving children more and more things to do because they seem to expect
it, and in so doing to give teachers the knowledge and confidence to work
differently.

I believe that the more teachers are able to allow children to work from
their own observations, ideas and feelings, the more they will see children
achieving personal levels of skill and knowledge in their art. For many
teachers, however, when this begins to happen they can feel more lost and
unable to cope than when they directed everything that was done.

As teachers release direct control over how children respond in art their
influence begins to work differently. Having relinquished their role as
sole arbiter of what is done, many teachers use systems of approval and
acknowledgement or incomprehension and dismissal to maintain some
control over what is produced. Children are left to 'read the signs' as to
what is successful or good and are given no clue as to what might improve
their understanding and performance.

It need not be like this, and it is hoped that many teachers will be given
the confidence to see and try other ways of working from the ideas in this
book. The prime argument of this chapter is that teachers should consider
how they might raise levels of awareness and intelligence about art in the
children they teach.

Perhaps the change of approach that learning in art seems to require is

not helped if the basic approach to teaching is one which substantially organizes, arranges and directs what children do and how they do it. This kind of approach leads to making judgements about how work is done and what results are achieved, the setting of tasks to be completed and directions to be followed for success. Inevitably, it is to the teacher that children will turn for recognition and approval, for ideas and opinions and for comment on their work. In the sphere of art education it is my belief that the pattern of unsubstantiated opinions, judgements and rhetorical comments and questions which follow this sequence do very little to raise children's levels of understanding and may operate against them.

Here again the teacher takes a central role in forming children's attitudes and building their confidence. Comments and asides and the manner of handling of completed pieces can, unwittingly, place the teacher in the wrong relationship to the creative work children do. Comments such as 'I like that part', 'That's a nice painting', 'Those are beautiful colours you've found', 'If you've finished, clear away' come across as judgements and personal opinions, neither of which tell the children anything about art and certainly do not increase their understanding.

The parts the teacher likes may have been mistakes or overlooked by the child; the beautiful colours taken from another child's mixtures with no feeling of how they might be made; and the apparently finished piece may have been abandoned, or it could be posing a potentially interesting problem for teacher and child to solve or be the result of an exciting personal discovery.

It requires the mediation of some conversation about the children's experience, preferably based on teacher observation of the processes of painting, for this situation to change. Conversations can start in all kinds of ways, but conversations about painting require at least the rudimentary observation of children handling paint.

It is appropriate now to look in more depth at the two considerations about learning already stated and in doing so to propose ways forward. Some exploration of the following topics seems to me to be central to any understanding of how to manage learning as an active process and work confidently with children's creativity and imagination.

(A) *Learning as an active process*
1. the interactive or dynamic approach to teaching rather than the directive, knowledge-based and linear approach;
2. awareness of the kinds of developmental changes that occur in children during their primary school years as they impinge on their art making.

(B) *Working with the creative and imaginative aspects of children's learning*
1. the influence of media and materials on ideas;
2. communication through media and materials;

47

 3. the function of first-hand experience;
 4. visual and aesthetic aspects of making.

In what follows examples drawn from painting will be used as a paradigm for working in art, craft and design.

Learning as an active process

THE INTERACTIVE OR DYNAMIC APPROACH TO TEACHING

At one time large Victorian school buildings stood as monuments to a particular view of learning. In one town where I worked as an adviser, there is a particularly fine example of such a building, which had celebrated its centenary prior to being refurbished. The classrooms exhibited raked, wooden panelled dados redolent of a time when the teacher, as instructor, stood at the front of the class and taught from a base of knowledge to be learned, remembered and recited.

In this climate painting (art) was by instruction, demonstration and example to be followed. There was no room for personal interpretation, invention or displays of imagination. In this circumstance the uniformity of the results demonstrated the success of the teaching.

If one looks at books on art teaching published in the 1930s, the effects of this approach are still much in evidence in simple pencil and pastel exercises to be completed and instructions on composition and design. In one such book it is suggested that in drawing a bunch of five overlapping balloons in pencil from a demonstration on the blackboard, the children should make a small composition first, and only when the teacher has corrected and approved this piece should a larger one be attempted. This book, *Art in the Primary School*, also states that 'Water colour as a medium need not be attempted with classes under 10 years of age.' It is suggested that flat washes should be attempted and that to paint the outline drawing of balloons would give good practice in 'laying in flat washes' (Smyth, 1936, p. 100).

This approach shows that the teacher would have a clear knowledge of what has to be taught and how it is to be learned. The teacher's perceptions would be unsullied by thoughts of how children might respond, whether they will have their own ideas and ways of doing things or how to judge a range of different results. The success of the teaching will be shown in the uniformity of the results. The teacher's *perception* of the task (what is to be learned), based on his/her experience and acquired knowledge, is used to direct children to the *work* to be done. The children produce *results* which the teacher judges in the light of the task set. The following diagram sets out this approach in a very simplified form:

PERCEPTION ⟶ WORK ⟶ RESULTS

The approach to teaching here is directed and linear, with a simple pre-conceived result against which the teacher can judge children's endeavours and make assumptions about what they have learned. This approach is not active in the sense described, for no deviation from the set task is allowed, no personal response is looked for and no displays of imagination are tolerated.

If, on the other hand, one believes that for teaching to be effective learning must become personal and can only take place when the learner responds, the above approach will not suffice. It is generally believed now that the perceptions of the teacher are used not just to determine what is to be taught but to excite the responses and interest of the pupils. Associated with awakening children's responses are other important notions about how teaching becomes effective, such as:

- the power of motivation through interest and appropriate levels of stimulus;
- the assimilation of new learning into personal patterns of understanding;
- the generation of ideas which pick up on the teacher's perceptions of the task; and
- ways of working which develop ideas through children's own observations, understanding and their developing knowledge and skill.

In fact, teachers whose purpose is to excite the creative endeavours of their pupils read these signs for the success of their teaching. That is, when children respond, show interest, use their senses with individuality and confidence, and begin to devise their own ways of handling materials to work out ideas and observations, the teacher feels that learning is taking place and that his or her teaching is effective.

The contrast between children given templates to fill in with ready-mixed paint and children having containers of powder colour from which to mix their own colours and make their own marks, exemplifies the difference between these two approaches to teaching.

This situation also reveals the areas where teachers can encounter difficulties, for to allow young children to mix their own colours and to make their own marks can lead to problems if the experience is not carefully managed. Chapter 7 discusses how this might be achieved.

There are a number of 'side effects' which should be noted when teachers work through children's responses to achieve learning. It is difficult to predict children's responses except within certain broadly defined areas, so teachers

need to have thought about strategies to cope with deviation from the task set and variations on the work they are expecting children to do. The range of responses may also be much wider than anticipated and may lead to an extension in physical time, resources and requirements of space beyond where the teacher wished to go. To curb such excess arbitrarily may have the opposite effect on the way children work, dampening their enthusiasm and leading them to make more demands of the teacher.

Some children may become lost and frustrated, unable to manage the freedom of choice and openness to work, and may require more support if they are not to feel that they are inadequate to the task. If teachers feel it is right to work through the responses children make to their teaching, then further thought must be given to what this means.

Somehow, it seems, teachers need to find approaches which confine or direct children's responses within the limits of the work to be done without losing the personal motivation and interest such responses bring. Superficially, this may appear to suggest a contradiction, especially as it is common experience for us to have our perceptions (ways of seeing) misunderstood by the responses of others, and for us to misunderstand others' perceptions in the way we respond to them.

To give an example: a group of children start to mix oranges and reds after being stimulated to do so in various ways such as looking at coloured objects with a variety of reds and oranges. Amongst the group are those who continue to question and talk about what is required as if trying to 'tune themselves in' to the task. Others follow a lead given by more adventurous or confident children, put water and paint together and start mixing. Yet others will seem to have forgotten what they are supposed to be doing and just enjoy mixing for mixing's sake, not recognizing that yellow and red might have any significance over other colours in the task set.

This pattern of varied activity often takes place when children's responses are sought, however thoroughly or carefully the stimulus is presented. The power of teachers' perceptions to initiate and sustain a piece of work from the responses of a given group of children cannot work in the linear way that the directive approach does. In what other ways do teachers deal with this situation?

Moving amongst the group, the teacher tries to be positive, recognizing 'good' pieces that accord with his or her perceptions of the task (maybe holding these up as examples to influence other, more wayward pupils), seeing good in effort and answering questions like 'Is this right?' or 'How do you . . . Where can I find . . . ?' As the teacher takes in the whole situation he or she is aware that several children aren't even mixing reds and oranges! Not only this, but the teacher has felt his or her own inadequacy and ineffectiveness in responses to the work of many pupils.

Is one answer to be more explicit and actually demonstrate how to make reds and oranges, for even with red and yellow in front of them many children don't seem to achieve what is required? Feeling that showing a technique for mixing the colours might help, the teacher can still be surprised when this intervention doesn't seem to help some children, for the levels of skill and understanding they bring to the task lead them to continue with random mixing without, apparently, getting anywhere. To give children's work a positive direction often requires more than just teaching a technique.

I believe that in whatever way teachers' perceptions stimulate children's responses, the resulting pattern of learning will be varied and, within the broad guidelines, random. Where a technique or method is demonstrated to reaffirm the direction of the activity, the results will be varied and random. The following diagram sets this out in a very simplified form:

$$\text{PERCEPTIONS} \rightarrow \underset{\substack{\text{producing} \\ \text{varied} \\ \text{RESPONSES}}}{\text{WORK}} \rightarrow \overset{\text{demonstrated}}{\text{TECHNIQUE}} \rightarrow \underset{\substack{\text{producing} \\ \text{varied} \\ \text{RESULTS}}}{\text{SKILL}}$$

The pattern of activity arising from teaching through children's responses shows evidence of learning in each of these four modes:

conversations and questions to clarify ideas, the nature of the task and what is expected (PERCEPTUAL);
direct action with ideas and purposes apparently firmly in mind and involved, purposeful actions to realize them (RESPONSIVE);
requests for information on approaches and methods, trying out ways of doing things, copying and following others (TECHNICAL);
activity with the materials, exploring and experimenting with them with no apparent end in mind other than to enjoy the sensations they provide or the effects they produce (SKILFUL).

However one analyses the range of activity, I believe that we begin to see, in this analysis, a truer explanation of what takes place when teachers work through children's responses. The teaching becomes interactive (witness how the teacher moves into and amongst the class group and does not stay at the front of the class), and the learning becomes dynamic (pupils' learning moves continually through the activities of responding, perceiving differently, practising skills and devising, inventing and experimenting with techniques).

If this analysis presents a more accurate picture of what actually takes place when teachers work through and with children's responses then a number of other propositions follow.

In order to initiate creative work with children, teachers do not work

Figure 5.1 *The relationships in dynamic or interactive learning*

only through children's responses but also through children's perceptions, their enjoyment and practice of skill and the inventive potential of techniques.

In a given group of children, some will start their art making in each of these four modes of learning; that is, some will respond directly to the ideas and stimulus, see and feel what they want to do and how to set about it; some will want to carry on talking about and sharing the stimulus, heightening their ways of understanding it before they commit themselves to starting with materials; others will conceive possible ways of tackling the task and want to ask about technical things or try out and invent methods for solving it; and yet others will move directly into handling the chosen material to explore it for its own sake, revelling in the practice of their skills in managing the material.

This may sound complex, but the reader is asked, whenever the opportunity presents itself, to stand back and observe children making art. It will be noticed that the development of any piece of creative work shifts between these four modes of learning in the process of its satisfactory completion. It is, however, likely that children will 'get stuck', frustrated or happily lost in any one of these modes and this is where teachers can be most effective in their work, spotting the point where this happens and sensing how to act.

I have often been asked about what to do with a child who seems to want to mix paint endlessly and does nothing more. Or questions have arisen about children needing to be shown more techniques or having no

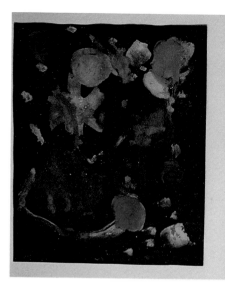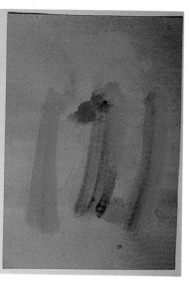

1 There is much to see and talk about in these paint explorations: the colours change when painted on black or on top of each other. When mixed with water they have transparency and their covering power is developed. Powder is sprinkled and water brushed on. (5–6-year-olds)

2 Following a maths lesson when children looked at and discussed the properties of a variety of plane shapes, they looked at reproductions of paintings by Paul Klee which were made up almost entirely of geometric shapes arranged in a rhythmic and harmonious way. The children were greatly impressed and proceeded to create their own patterns. (5–6-year-olds)

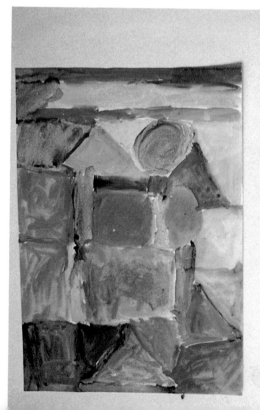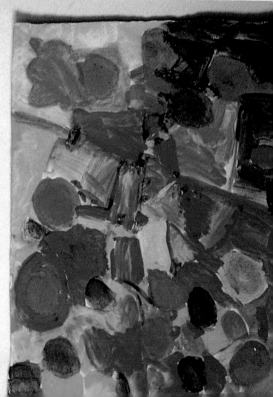

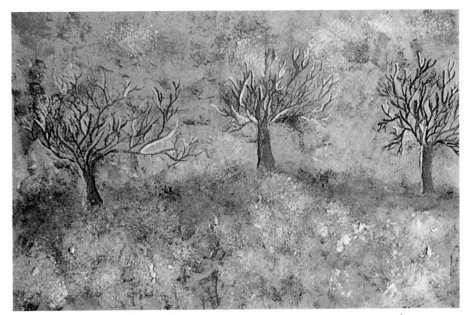

3 The children experimented with powder paint using sponges to produce mixtures for sky effects. The palette was reduced to two blues, white and crimson. (10–11-year-olds)

4 In science children studied the same patch of sky over six weeks and recorded their findings. During the same period the children experimented with powder paint, mixing cold colours and adding watery colours on top of each other. (10–11-year-olds)

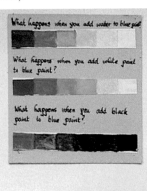

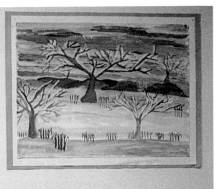

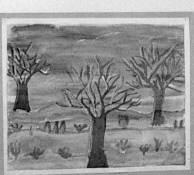

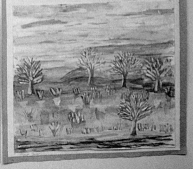

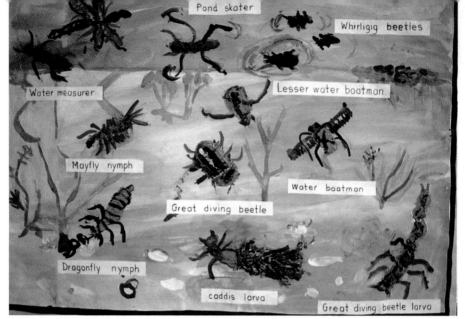

Pond skater

Whirligig beetles

Water measurer

Lesser water boatman

Mayfly nymph

Water boatman

Great diving beetle

Dragonfly nymph

caddis larva

Great diving beetle larva

5 Pond creatures were taken into the class by the teacher for children to study as part of a science project. Magnifiers were used along with books to help identify specimens. Paintings were made subsequently and a larger panel for display in the school hall. (6-year-olds)

6 A number of children were stimulated to make their own, individual paintings. This painting shows great control over the medium: the wet-in-wet paint conveys the watery environment. (6-year-old)

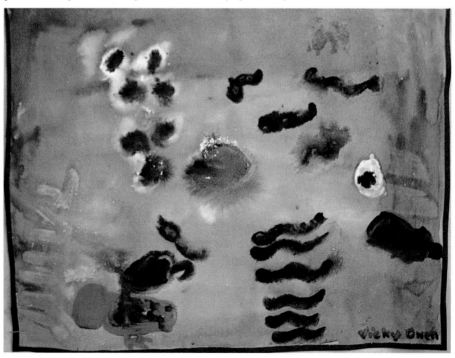

7 Experiments with brush patterns and paint textures in preparation for the painting, based on close looking at the owl. (10-year-old)

8 In science children looked closely at bricks and carried out experiments with them. Drawings were made of local buildings with different types and patterns of bricks. The children matched colours, made houses from clay, and made drawings and paintings. (10-year-olds)

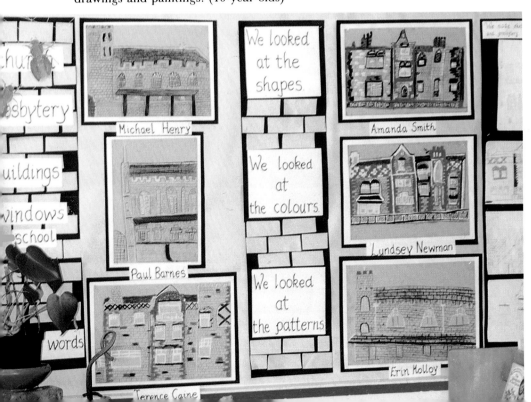

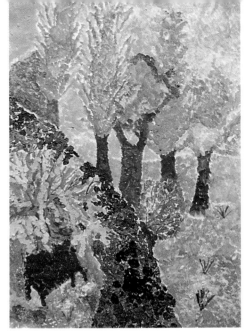

9 Concentration on the richness of colour and texture is evident in this painting. The way paint is mixed thickly and applied gives intense satisfaction to many children. (10-year-old)

10 The thick texture of mixed browns and oranges which can be seen in autumn; but the paint itself can change the way we look at autumn. (10-year-olds)

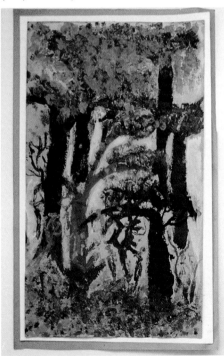
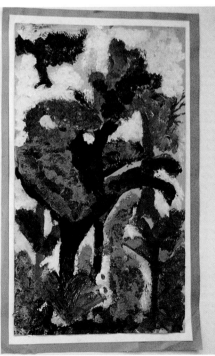

11 Painting of the local church using a technique for handling the medium which had been introduced to the children by an artist. He had worked in the school, with and alongside the children. (10-year-old)

12 Flower paintings showing controlled and subtle use of washes of colour. (10-year-olds)

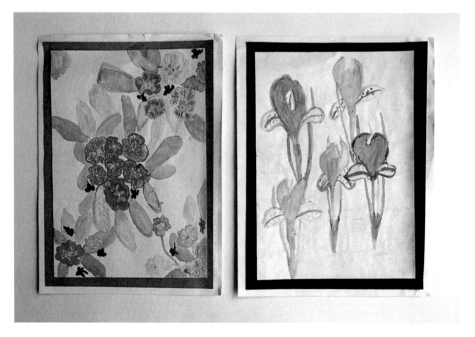

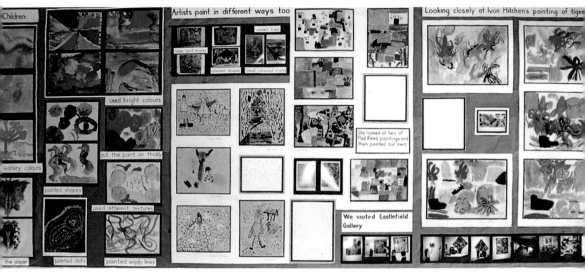

13 A display of paint explorations and paintings which were stimulated by looking at and discussing reproductions and prints of the work of artists, and by a visit to a local gallery. (6-year-olds)

14 Children discussing their paint explorations, examples of which are on the wall behind them. (6-year-olds)

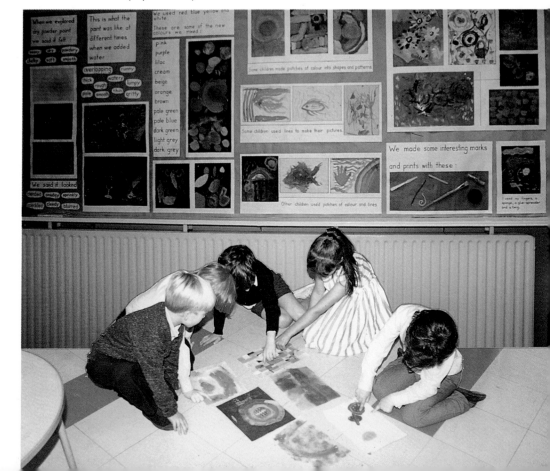

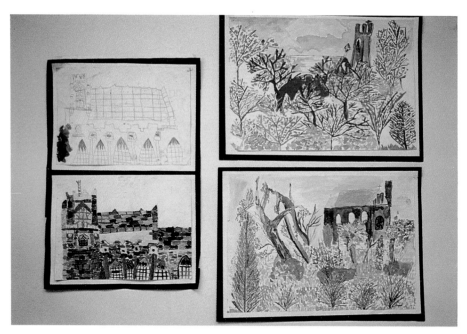

15 Pencil sketch of the local church made on the spot, and later developed into a painting. Enjoyment in colour mixing and brush textures is evident in these pieces. (10-year-olds)

16 A general view of the junior classroom. In the far corner is the sink area. Pupils tend to work in groups, though not always. Note the quality of the display. (10-year-olds)

ideas. Such comments are evidence that the learning has got stuck and that the teacher's observation and understanding of what is happening is limited.

Although teachers may, at times, initiate practical work with the whole class, it is not the wisest course for the whole class to do it at the same time. Both in seating arrangements and in how they move amongst the class teachers will work with individuals and small groups (see Chapters 2 and 4). In this way, they can respond in each of these four modes and will sense how one or other of them is operative with any group or individual.

For example, in one instance they may merely observe the level and direction of a child's response. To more than acknowledge it would be superfluous, and intervention may stop it as personal responses often have their own power and momentum. If the response activity seems to be weakening, a word of encouragement may be enough; if it is changing, more may be required.

Responses may be changing because the medium is getting out of control. Then some technical/organizational help may be required, such as laying the painting down or mixing the colour more thickly. This could lead the child to experiment and practise mixing in order to solve the difficulty.

It might be that the idea the child had in mind is weakening, or that in that particular paint statement it is as complete as it can be. Here a comment about the idea behind the response, what the child had in mind, would seem appropriate. If the child's perceptions have weakened through the process of making, perhaps more looking and sharing and talking about the starting stimulus is required.

Lastly, as the teacher moves amongst the class it is noticed that some children are getting in a mess: maybe just stirring the paint up, but nevertheless completely absorbed. These children seem to be revelling for that moment in the very nature and sensation of the material. All that may be necessary here is to provide more and stiffer paper, or perhaps card, which doesn't go as soggy when it is worked on. Several sheets of newspaper under the painting and frequent changes of water would also help. This kind of enjoyment of paint is usually immediate, often vigorous, and can soon be over, requiring the replenishing of paper, paint and clean water. As the activity changes it is important to share what has taken place, the discoveries made and the problems faced. The work should be 'rescued' from the surrounding working chaos and placed on white paper, the better to see it.

I remember watching a 6-year-old painting in this way and had a positive and interesting conversation with him about all the greys he had found and which colours he had used. After the session I wanted to share what he had done with his teacher but, alas, his painting/colour mixing/mark making had become stuck to the back of other work hurriedly piled up at the end of the session. His discoveries may have been transitory and limited

e them with the teacher and the class could have given them a
value from which his confidence to develop further could have

My attempt here is to explore what actually happens when children paint
(use materials creatively) and how teachers might interact with their activity.
This pattern of teaching is difficult to set down but I hope sufficient has
been said to suggest that teachers have to *observe* and *listen* as much as talk
and intervene if their understanding of how to teach interactively with
children's art making is to develop. They should bear in mind that:

(a) not every child requires the same 'advice' at the same time;
(b) there are moments when quite simple actions have powerful effects,
for good or ill, and that it is only by trying to work through the
four modes of learning described that teachers will see what to do
and sense when to do it.

Teaching art in an interactive way and allowing the children's learning to
be dynamic places a premium on teacher observation. It is through obser-
vation that their interaction will become more sensitive and informed, and
therefore effective.

All that has been said here depends on how teachers understand the
changes which take place in children's growth and development.

AWARENESS OF DEVELOPMENTAL CHANGES

Teachers are bound to be aware of the proposition that children learn in
different ways at different stages of their development. In some primary
schools teachers will move between age groups, which enables them to
get a clear picture of the differences in learning between, say, infant
(5–7-year-olds) and junior-age children (8–11-year-olds). The differences
on which I want to focus are those which become evident in children's
art making.

Many influences affect the visual and artistic maturing of children, from
the home environment, through the many public and commercial media,
to the predisposition and opportunity to handle materials. Children are
surrounded by all kinds of visual stimuli and many direct appeals to excite
and impress them through simplified, adult visual stereotypes. Even quite
young children will pick up and imitate visual clichés and they can appear
in the drawings of early infancy. As Rhoda Kellogg states,

Mothers, fathers, older children in the family, relatives and friends are the
persons whose attitudes towards scribbling can affect the child. Their attitudes
are the result of their own experiences with art in early childhood both at home
and in school.

Coloring books help to fix in the child's mind certain adult-devised formulas for representing objects. Picture books, magazine art, newspapers, comics and television's animated creatures all have similar effects. (Kellogg, 1969, p. 144)

The purpose here is not to dwell on the complexity of child psychology and development but to alert teachers to two main issues which can help them in their art teaching:

1. The human mind develops in particular ways through the ages of childhood. This development is revealed in children's ways of perceiving and thinking about the world around them and can be seen in their mark making. Knowing something of this development, teachers will be better able to understand and work with such changes as they occur and will recognize the need for some children to revert or live through earlier stages which may have been denied them, before they can truly progress.
2. Knowing about the kinds of changes which might occur can enable teachers to look more discerningly and confidently at children's art making without feeling the need to compare it with more sophisticated or adult forms or to make comparative judgements between the pieces produced by different children in the same group.

Children can reveal an enormous amount about their perceptions, understanding and capacity to learn through their artwork, particularly mark making and drawing, which comes so easily to hand. The particulars of a piece of art which the teacher notices can be drawn into conversations about it and can demonstrate to the child a quality of sharing from which all benefit.

CHILDREN'S DEVELOPMENT SEEN THROUGH THEIR ART MAKING

Young children enjoy playing in an exploratory way with materials of any kind: their food, the hair of the pet, garden soil and mark-making materials like pencil and crayon. The early mark making is full of tactile enjoyment and visual wonder and directed by simple movements of the hand, wrist, arm and body. As the mind explores new sensations it forms patterns which lead to recognition and simple forms of control, evident in repetitions. This ordering or patterning of sensory experience continues rapidly and lies at the heart of young children's 'intelligence' about the world in which they find themselves.

Early mark making soon shows evidence of ordering in the more controlled loops, squiggles, knots and outlines of children's drawings. It is from these early configurations that children build up a vocabulary from which diagrammatic representations arise, which are referred to as schemata.

Schemata remain in the vocabulary of all of us throughout our lives, to be drawn upon in most unlikely circumstances: to give directions, take part in games or make visual notes, for example. We must not think of schemata as just childlike, for they function as a shorthand for all of us, conveying a range of information which words cannot manage as well.

However, schemata are easily added to or taken over by adult clichés and stereotypes, which are not the same. The latter are oversimplified and often badly and crudely drawn and not well observed, whereas personal schemata result from direct experience and involvement. Witness the difference between the double curve which stands for a flying bird, so common everywhere, and the drawing a child will make after having seen birds in flight.

Schemata are added to significantly through direct experience and first-hand observation, as can be seen in the pond-life paintings by 6-year-olds taught by Anne (Plate 5 and 6). The schemata children employ arise from their mark-making vocabulary, to which is added an accumulation of information gleaned from the object: a wheel on each corner of a rectangle for a pram; claw feet for a landing bird; rows of buttons for the teacher.

Children's schemata develop in range and complexity as children's visual language grows, rather as their verbal language grows through their handling of and exposure to words. Sharing mark making, drawings and paintings with children, both their own and those of artists, and enjoying the experience of mark making for its own sake, is similar to the way teachers handle language development through sharing stories and poetry by writers as well as pieces the children have written themselves.

Healthy, happy children seem always to be curious about the world in which they live. Part of this curiosity is seen in their imitative and inventive play. Often their drawings will be full of invention using the language of marks and schemata they have evolved and imitated. Their drawings will become more complex and detailed as their mark-making language is put to wider and more varied use. A new experience will invariably produce an extension to the mark-making repertoire, and drawings and paintings will carry whole episodes of events as well as the directly observed features of a person, place or object.

Around $6\frac{1}{2}$ and 7 years old a marked change takes place in the way the human mind perceives the world and processes the information about it. Whereas very young children see and respond to the immediate viewpoint and how they are affected by it, now there will appear more questioning and investigation. Seven-year-olds are known for their avid questioning of everything, which shows their ability to build mental concepts about objects, places, things and people independently of their direct experience of them.

This feature of their development means that they begin to use their own ideas and imaginings to explain the world around them. These self-explanations, derived from any source (adults, television), are used to explore, examine and reconstruct their view of things. One example of this change in mental ability is seen in children who begin to play games to rules, share and collaborate, hold ideas in mind and begin to plan and visualize possibilities.

All these changes are manifest in their art, where on the one hand anxiety about right and wrong drawing, correctness of shape and representation begin to demand attention, and on the other there is an acceleration of their particular knowledge about specific things, whether horses or trains, people's mannerisms or the working of machines.

This is a time when children can get an enormous amount from sharing the work of artists. Their questing curiosity searches out the whys and wherefores of images, enjoys representations and seeks to understand the interpretations, the methods and materials used; they want to try things out for themselves and in their own way. They can easily be put off by an overbearing emphasis on technique and on doing things properly yet enjoy inventing their own ways of doing things and sticking to the rules they devise for doing them.

The rapid development of concepts with which to understand the world around them is registered in the importance placed on ideas. Ideas are used to interpret experience, to scale it down to manageable and comprehensible proportions. Another function of ideas is that they become a strong moti-vating force; personal ideas seem to focus and direct energy as can be seen when watching children (post 7 years old) at play.

Children of 7 enter a period of adventurous exploration, of inventiveness and of rapid increase in what they know and understand about the adult world around them. This condition is ideal for teaching them about art, craft and design; helping them to enjoy a new-found co-ordination with tools and to satisfy an appetite to solve problems, make collections, invent and make objects.

As children handle paint, explore its potential and experiment with its characteristics, their knowledge and understanding of paint as a medium can expand considerably at this time. Coupled with their increased skill at manipulating tools, this is a period when positive teaching pays dividends.

The continued experimenting with paint Sandra found to be essential for her pupils. It is through this that they found the colours and transparencies of cold winter and the heavy impasto of autumn trees. Their investigations into the colours and patterns of bricks were part of the business of looking at them scientifically, learning other things about them and painting them. Painting alongside an artist led to new techniques for handling paint by

t off the surface and working into it. These were two of the specific
its in Sandra's teaching which went into the development of these
ngs (Plates 3, 4 and 11).

This is a period when there has to be a directness and honesty about
what teachers want children to learn and how they set about teaching. Solid,
real experiences of places, events, artists' and designers' work, people and
the way they do things are sought rather than unrelated techniques, isolated
craft-type activities, filling in and fantasy. The teacher has to have a clear
recognition that experiments are necessary but that they should be seen
for what they are: openings for discoveries to be applied and developed.
The experiments with paint marks and mixtures, the discoveries from which
fed into the painting of a stuffed owl, are an example of the approach used
by Sandra with junior-aged children (Plate 7).

WORKING WITH THE CREATIVE AND IMAGINATIVE ASPECTS OF CHILDREN'S
LEARNING

The influence of media on ideas

A drawing of a tree in charcoal is as much a series of charcoal marks as it
is a representation of a tree. Likewise a painting of a tree will be dictated
by the nature of the medium (paint) as much as by the configuration of the
tree. Herein lies a simple truth yet one which must not be overlooked:

As the observation shapes the medium, the medium shapes the observation.

Any stimulus, whether from direct perception or the imagination, is always
changed and modified by the medium through which it is communicated.
Ideas grow and develop because they are changed through their communi-
cation, as communication is extended through the ideas one wants to convey.
Ideas are formed in the medium as the medium shapes the ideas.

It follows from this proposition that working with a medium can develop
ideas as much as the other way round. In fact, the development of skills
and a language of marks in paint can change the way individuals look
at the world around them. The intensity and rhythmical brush strokes of
a Van Gogh cypress tree make us see cypress trees differently; David
Hockney's paintings of swimming pools change our perception of water
in swimming pools.

It is vital that, at all stages and all levels, children are encouraged to explore
paint, experiment with it and apply it in their own way. What they discover
through this experience is not just how paint behaves and what can be done
with it but the imaginative possibilities and applications that emerge from
the experience.

Paint runs and smudges, intermixes and flows together; it can be brushed
on in delicate, see-through washes or laid on in thick, chunky strokes. The

paint surface can be scratched into, have materials mixed into it and can be scraped away and blotted. It is not that any of these things have to be taught or shown, but that considered experimentation with paint as a substance and an open sharing of the discoveries should be encouraged and planned for. Experimental sessions should not be one-off events or lessons which last for a long time. It is more important to see them as short, repeated opportunities to extend knowledge and understanding of a medium, as described elsewhere in this book.

The build-up of a personal vocabulary and intelligence about the medium are crucial if the power of the medium to influence ideas is to be fully exploited.

Communication through media and materials

Children who have had the opportunity to mark-make and draw will have built up a repertoire of marks and schemata. Often children will reveal more of their knowledge and observations through their drawings than through their spoken language. Apart from this, drawings can show an understanding of visual and spatial qualities like texture and surface, shape and pattern, size and relationship, all things which words do not convey with the same ease. In many cases children may have a more elaborate and developed visual language than verbal language to set down what they see and experience. Drawing and painting, by their nature, are holistic and image-based forms of communication whereas words are sequential and linear. So there are many things that children can express through a confidence in drawing and painting that they may not through words. But this is not the only kind of communication which media make possible.

Between our own private, inner experience and public outer events there is a gap or space to be bridged, and in some cases a chasm to be crossed. We all need to communicate with another or others. There are many things hidden in our lives, and especially in the lives of children, which need to be communicated, but many children either feel too anxious or frightened to communicate these or do not have the range and versatility of language to give them form.

Words are the most obvious form of communication, exact in their power to direct, inform and explain – but even words have to create images to communicate some things which simple descriptions cannot convey. The response to some deeply moving experience demands more than description or cliché; it requires words to be given context and meaning through metaphor and image.

It is so with any medium which carries ideas, responses and feelings as well as information, understandings and so on. The visual media, including

paint, offer a direct, expressive and tactile form of communication to which children readily respond. Paintings, like any visual art form, use and carry descriptions but are primarily a way of conveying other kinds of meaning associated with personal response.

The function of first-hand experience

Recording what has been observed and even closely investigated was, and still is, a significant approach to art in primary schools in many parts of the country. Some education authorities were known particularly for the excellence of children's observed work and supported this approach through loan collections, museum services and the like.

There is no doubt that providing many different categories of objects (historical, domestic, natural, industrial, original works of art) in schools and classrooms stimulates a lot of art activity. Craft objects have also been used as pieces of real experience, together with visits to craft studios and craftworkers visiting schools where possible. The development of dyeing with plant and vegetable dyes, or paper making, are good examples of direct, 'hands-on' experiences which stimulate children's own creative work.

Designing and solving problems through materials can have similar starting points: for example, studying a hamster and beginning to understand its ways can lead to making a garden or adventure playground for it.

Learning from first-hand experience has special features that many primary school teachers have discovered and value. It takes time and effort to maintain the opportunity for good-quality first-hand experience and this is something which should be a whole-staff concern. This aspect of children's learning in art, craft and design is stated as an essential part of the National Curriculum (see Chapter 6). What is special about it?

A number of features of first-hand experience, which seem to me to be significant, are worth mentioning.

First, real experiences have the potential to engage all the senses; it is not just sight that comes into play for real things have a total presence, occupying space and position. It is not possible to say what special aspects will affect the viewer but the connections and associations can be as various as they are deep. Working with teachers on practical courses has revealed this facet to me: on many occasions individuals recalled something from their past, often childhood, which was evoked by some present, first-hand experience.

Secondly, real things – objects, places, events, people – have the capacity to attract and focus attention. The attention can become total and concentrated, and where this happens the recall seems to be of a special kind. It is not just certain features of the experience that are remembered but aspects

of its totality: the day, the time, the exact place and company and so on. If first-hand experience has the effect of leaving such long-lasting traces it must be educationally significant.

Thirdly, the apparent ability of first-hand experience to nourish the memory with images means that the memory store, from which visual ideas and inventions arise, is readily and richly fortified by such experiences. The experiences may not be differentiated into 'subjects' and so they have potential to support any aspect of children's learning and relationships between areas of learning, for example, science and history, technology and language, art and mathematics.

Fourthly, first-hand experiences can heighten awareness and sensitivity through the way sensory energy is focused: looking, listening and touching, smelling and being spatially aware can become sharper through contact with real experience.

Visual and aesthetic aspects of making

There are different elements to the form that visual communication takes: there is the reference to the things seen, observed and known; the visual approximations, interpretations and representations of people, places, things, environments and atmospheres and so forth. It is this descriptive aspect of visual communication which so often stands in the way of any real development of understanding of visual images and response to them. If one is not attuned to looking at images, too often one seeks the safe, the familiar and ordinary, the copy, exact representation or replica. It is the way that things are seen, felt and placed in new contexts that lifts mere descriptions into images that reveal a personal and committed viewpoint.

The other element of visual communication is the medium, the way it is handled and applied; the sensitivity and awareness, delicacy or purpose with which it is used. The potential of a medium is extended or enriched through the discoveries of artists; through it they register their particular feeling for a medium. In fact it is as much the individual's peculiar handling of the medium that gives pieces of art their special and very personal qualities as the things artists choose to depict.

It is the sensitivity of the person to the way the medium behaves and his/her continuous response to the forms and images it creates that one might call the aesthetic dimension of a piece of work. The actual things depicted, or the shapes, patterns and marks used, one could call the visual dimension. Neither the aesthetic nor the visual dimension should be neglected in teaching art; neither the particular manner in which pupils come to handle and respond to a medium nor the way they see and respond to visual ideas and stimuli.

If teachers tend to look at and respond only to the visual part of pupils' artwork, the things they paint and how well they are drawn, at least *half the experience of painting will be ignored.* As we have seen, visual ideas and ways of seeing and understanding grow from the handling of media. Media influence ideas as much as ideas shape media. *The aesthetic dimension records this effect as much as the visual dimension records what has been seen.*

The two major considerations about learning which have been explored in this chapter become important when teachers believe that they should engage children's responses when they teach. It is hoped that the ideas expressed here will enable teachers in primary schools to manage children's learning in art with confidence and increasing knowledge.

Painting and the National Curriculum

In his response to the interim report of the Art Working Group, the then Secretary of State for Education affirmed the government's view that art education should be provided for every child up to the age of 14. Thereafter, all schools should provide appropriate opportunities for art education 'for all who wish to take advantage of them'. Consequently, 1991 saw the value of art in the education of children confirmed in the provisions of the National Curriculum, which embodied the proposals of an Art Working Group appointed in July 1990 to specify the 'knowledge, skills and understanding which pupils of different abilities and maturities are expected to have by the end of each key stage'; also the 'matters, skills and processes which are required to be taught', and 'the arrangements for assessing pupils at or near the end of each key stage' (Education Reform Bill, Part 1, para. 2a, b, c). An array of Attainment Targets and Programmes of Study were drawn up by the Art Working Group within these parameters.

This chapter will look at the proposals of the Art Working Group and consider the main recommendations and approach of their report, their possible impact on primary schools generally and on painting in the primary school in particular. *Note*: recent developments are covered on pp. 91-4.

It is important to understand the context in which the report was made. In the introduction to this report a number of aspects of the comments by the Secretary of State in his letter to the chairman of the Working Group are worth noting. Concerning the resource implications of any recommendations made by the Working Group he notes that he would be concerned if 'the Group's desire to significantly improve practice in Art Education were to result in . . . an unrealistically wide range of work for all pupils and failed to permit pupils adequate scope for choice between activities'.

Many of those working in primary schools would feel that their practice has been to provide a wide range of materials with which to develop and extend children's experience, not just in art. Young children's making is often supported by experience in clay, sand, Plasticine, wooden blocks and cardboard boxes of various kinds, drawing and painting materials, fabrics and found or retrieved scrap materials. It would seem, therefore, that many primary schools are already offering adequate scope for choice but is the range of work 'unrealistically wide'?

The balance between a large variety of things to work with and quality

of experience has not always been struck by having a plethora of materials especially of the scrap kind. The comments of the minister may have financial implications in mind but also remind us that any range of materials should be thoughtfully considered and carefully selected. It is the variety of experiences which certain materials make possible, through their special and distinct properties and qualities, that should guide any choice.

This approach is explored more fully in *Children and Art Teaching*, where it is stated that 'The careful and considered choice of materials, both in range and quality, makes all the difference to the work children do in art, craft and design. It is necessary for the teacher to categorise materials in order that they can be grouped and stored and that the range is as wide as financial and physical circumstances permit' (Gentle, 1985, p. 170).

Two other points from the Minister's response should be noted, as these also shape the context in which the Working Group have reported.

First, although there is a clear recognition that the visual arts do not readily combine with the performing arts, the contribution to design and possible links with technology are encouraged and accord with the Working Group's view that 'the contribution of art to design and technology is fundamental'. Using materials to solve problems and work out ideas; experimenting with materials and discovering their properties and possibilities are direct and easily managed ways in which children, of all ages, enjoy and learn from materials. The fundamental knowing and basic skills in handling materials are the necessary starting point for technology as well as art.

Secondly, the Secretary of State has asked for a simplification of language and of structure in how the Attainment Targets and Programmes of Study are stated. This is important as it is the Attainment Targets and Programmes of Study which will guide and support the work of teachers and help them to communicate their aims, approaches and achievements to parents. Clear, unambiguous and comprehensible communication to pupils, parents and non-specialist teachers was asked for in terms of knowledge, skills and understanding. In some measure the Working Group achieved this in their rewriting of the interim report although non-specialist primary teachers will require help to unravel some of the technical language and the inevitable compressing of complex ideas into short sentences.

Describing how children are being educated in art in terms of knowledge, skills and understanding can make the task of planning their work and assessing it seem simpler and more straightforward than attempting to describe such things as feelings and responses. Knowledge can be specified and tested; skills can be observed and the results assessed; understanding can be questioned and checked.

The means for assessing knowledge, skills and understanding can be standardized, so that such issues as continuity of aims and content and

progress between years, classes and schools can be readily planned. The authors of the National Curriculum for Art claim that it will 'ensure common aims and consistency of practice'.

It is not easy to see how such important aspects of human experience as feelings, responses and imagination will be made assessable by the same criteria. The situation seems different when seeking to assess these elements as they arise in a piece of making.

How one assesses another's response in the art form produced or comes to an estimate of the depth of feeling or imagination expressed is another matter. Yet these things should not be ignored or overlooked.

One has to be aware that focusing on some learning experiences, because they seem easy to know and assess, can be deceptive, for there may be other qualities which should be considered as they affect deeply the learning that is going on. The visible signs of the activity are but the outcomes of a kaleidoscope of inner experiences: memories and associations, feelings and imaginings. Although some things can be specified and annotated easily, others, which might be of equal value, can be overlooked. A skilful manipulation of materials may impress but be lacking in any purpose or insight. It is the ideas and imagination which drive the handling of materials, and are revealed in their use, that give purpose and meaning to the activity. It is these aspects of making that most people would value as being more important than mere skill.

One can understand that a national scheme of assessment has to employ agreed criteria that are accessible to different people working in varied situations if it is to provide a common framework across all differences. Pupils' work will be assessed by these criteria and not against the work of others. Furthermore, the Working Group point out that 'When assessing achievements in art it is important to balance the relationship between the quality of the end product and the process of its making' (DES, 1991).

This kind of assessment, of process and product, goes some way to showing how aspects of making other than those of skill, knowledge and understanding might be assessed. Knowledge, skill and understanding will always be enriched and made personal in art education by the qualities of imagination, sensitivity and response that individuals bring to them. These qualities, so vital to any creative experience, may be better discerned in pupils when the process of making is considered together with the quality of its outcome.

The development of skills, the enhancement of understanding and the enrichment of knowledge are most likely to come about because of qualities of imagination, sensitivity, insight and perception and the way in which these are valued and supported. If some things are taught, others need to be nourished: the confidence to trust one's intuition or to reveal those things which grow and move in the imagination or the willingness to venture

an observation based on a sensitive appraisal – these need to be nourished if they can't be taught.

Often mature judgements and informed observations grow because of the self-confidence and good self-image of the individual or group. A class used to being supported by thoughtful questioning, sensitive observations and careful listening will be likely to exhibit the qualities of sensitivity, insight, perception and imagination which the Working Group hope will be encouraged. The Attainment Targets and Programmes of Study show that creative activity dominated by factual assessment, technical competence and skills developed alone will not satisfy the criteria of the National Curriculum. The Art Working Group make it clear (DES, 1991) that they value other qualities as well as these in children's learning and agree that

> art and design is concerned with visual communication, aesthetic sensibility, sensory perception, emotional and intellectual development, physical competence and critical judgement.
>
> Its particular contribution is concerned with, among other things, developing imagination and creativity; observation and the recording of images and through this the expression of ideas and feelings . . . the intuitive as well as the logical . . . [para. 3.6]
>
> Art allows them to give form to their personal response to the world. [para. 3.7]

If we now turn to the Attainment Targets at the first two Key Stages (Table 6.1) we will see further evidence of the broad view of art, craft and design which the Working Party have taken.

As with other core and foundation subjects in the National Curriculum, there is a broad matrix of Key Stages (the first two of which concern primary education), Attainment Targets and a range of learning experiences. Now that the context for these has been considered it is possible to look at them in more detail.

If we examine the statements of this end of the Key Stage matrix it will become clearer what is expected of teachers and their pupils. This more detailed look will also reveal points of reassurance, where correspondences with current practice can be found, as well as aspects that are new.

Paragraph 3.37 makes it clear that art, craft and design are consciously linked together from the earliest stages so that a narrow experience of just drawing and painting would not fulfil the requirements of the National Curriculum for Art. However, most schools provide a wider range of experiences other than drawing and painting, although they may not recognize all these experiences as art. For example, making things from Plasticine or cardboard boxes, sand or clay can fulfil aspects of art, craft or design. This is especially so if the reasons for children handling materials other than those for drawing and painting are extended beyond basic forms of expression, to solving problems and exploring qualities of materials.

It must also be pointed out that the National Curriculum Art Working Group conceived of art education as having three mutually necessary aspects: understanding, making and investigating. (This has since been altered, by the Minister, to two pairs of aspects: knowledge and understanding, and making and investigating.) These aspects are not in any priority order but teachers are required to provide children with some experience in all of them. A school's staff will have to work together to decide if and in what way they are already working at some parts of the Attainment Targets and what more is necessary. This is the first concern that must be addressed. It is not sufficient to leave children to 'get on' and assume that their *understanding* will grow or that the purposes and skills of *investigation* will develop on their own.

It would seem a sensible notion to review the materials that are provided in the school already and set down the kinds of thing children do with them, alone or with their teachers. Alongside such an inventory, those parts of children's experience which can fulfil parts of the Programmes of Study can be noted.

It is likely that there will be common ground in many aspects. Rather than staff becoming anxious about what they imagine is expected of them from a whole series of targets and programmes, it makes sense to talk through what the attainment targets require; in doing so it will be possible to:

1. identify those areas of experience which are not being covered;
2. see where work in one area satisfies the criteria for another. For example, talking about a piece of art in English; making a model as satisfying part of an attainment target in technology; exploring materials as part of science and so on;
3. recognize how the whole group of staff will collectively work towards the Attainment Targets from 5 to 7 or 8 to 11 or even 5 to 11, depending on the type of school. It is not and should not be the responsibility of each teacher, especially those with 7- and 11-year-olds, to take on all the work of the Attainment Targets alone, in one year. Each teacher will recognize, through discussion, how they will add to the cumulative progress and continuity of work throughout the years children are in the school, and keep some record of what is done by each child. What kind of notes and how to keep a record of children's work in art will be considered more fully in the discussion on assessment in Chapter 7. Such staff discussion and collaboration should also build on the strengths of those with interests and knowledge of one area and add to the confidence and knowledge of others.

Another aspect of the Working Group's view of art is that the processes of making are seen to involve implementing changes, making modifications

Table 6.1
The broad matrix of the National Curriculum for Art as it affects primary schools derived from the end of Key Stage statements

	Key Stage 1	*Key Stage 2*
AT1 Understanding	*Pupils should have demonstrated that they can*	
Pupils should be able to evaluate and use practically and imaginatively in their own work the approaches of other artists, craftworkers and designers working in diverse contemporary and historical cultures and contexts.	(a) begin to make connections between their own work and that of others, including artists, craftworkers and designers; (b) recognize that there are different types of art, craft and design.	(a) use imaginatively comparisons between the work of other artists, craftworkers and designers in order to inform their own work; (b) recognize how the work of artists, craftworkers and designers is influenced by the different cultures, contexts and times within which they work.
AT2 Making	*Pupils should have demonstrated that they can*	
Pupils should be able to use the skills and knowledge involved in the process of making (including the ability to select and control the use of materials, tools and techniques and an understanding of the visual language of art, craft and design) and apply these in their own work to develop, express and modify their ideas, intentions and feelings.	(a) work practically and imaginatively with a limited range of materials and tools and explore basic aspects of the visual language of art, craft and design; work individually and in groups to make large- and small-scale work in two and three dimensions; (b) implement simple changes in their work in the light of progress made.	(a) apply a basic grasp of the visual language of art, craft and design and of the variety of technical and expressive outcomes that can be achieved when a range of materials and tools are used; work individually and in groups to make large- and small-scale work in two and three dimensions and, where practicable, in time-based work; (b) modify their work in the light of their intentions, the choices involved in the making process and the results.

	Key Stage 1	Key Stage 2
AT3 Investigation	*Pupils should have demonstrated that they can*	
Pupils should be able to develop their visual perception, recording from direct observation, memory and the imagination and visualize ideas drawing on a wide range of resources which they have selected from the natural and man-made environment.	(a) record images and ideas from direct observation, memory and the imagination; (b) use a range of items they have collected and organized as a basis for their work and talk about what they have done.	(a) select and record images and ideas from direct observation, memory and the imagination, using a range of materials and methods; (b) prepare and develop an idea or theme for their work by collecting and organizing visual and other resources; discuss their methods.

A simplified scheme of the main activities and how they might progress		
AT1 Understanding	make connections between recognize differences	use comparisons to inform recognize influence of differences
AT2 Making	work with a limited range; explore basic aspects implement simple changes	modify work apply basic visual language and range of materials and tools
AT3 Investigation	record use a range of items; talk about	select and record; use a range of materials and methods prepare and develop; discuss methods

The 1992 revision of this broad matrix is shown as Table 6.A1 on pp. 93–4.

and reviewing what is done. For many teachers, the path to a pupil completing a piece of work will no longer be that of just filling in the spaces, being content with the first mark or making do with the first solution that comes to hand. The clear expectation here is that teachers will talk over the making with their pupils, encourage them to look more carefully, to reconsider and add to the work they have done. The development of an art vocabulary to aid discussion and questioning becomes important but, as I will show, such a vocabulary can grow through the natural conversations and exchanges that occur about the things children are doing.

Working from direct observation and collections is now necessary as well as working from imagination and memory. Although many primary schools have used objects from museums and other sources and teachers' personal collections, the way in which children should be encouraged to select and bring together collections of their own or to use objects and collections as part of their art, craft or design will be a new departure for many teachers. I will discuss what is implied in this development, covering topics such as how to stimulate and manage collections, strategies for phasing in such experiences for a class of thirty or more, and will suggest the kinds of conversation which might arise.

This change in approach will eventually be essential for Attainment Target 3 to be achieved, where 'pupils should demonstrate that they can prepare and develop an idea or theme for their work by collecting and organising visual and other resources'. They will be expected not only to do this but to discuss the methods used. The attitudes pupils acquire from achieving Attainment Targets 1 and 2 should lead naturally to their approach to achieving the demands of Attainment Target 3.

Developing an understanding of art (Attainment Target 1) requires a positive approach to looking at and talking about the work of artists, craft-workers and designers. This is another area which many primary teachers, especially those without any art experience in their specialist training, will find difficult to handle.

If teachers have not themselves spent time with the work of artists, craft-workers and designers, how and where to start developing children's under-standing of art could cause anxiety. This is particularly so in knowing what to say or what to ask about a piece of work. It is my experience that this area, once entered, will yield many delights and surprises, not least in the imagination, honesty and spontaneous delight that young children bring to looking at art.

Children's responses to real experience often obviate the need for the teacher to say or reveal anything. After all, it is the children who are doing the looking and this may require little from the teacher initially except careful listening and observation and a sharing of curiosity and enthusiasm. As

Table 6.2
Progress and continuity as seen between the Key Stages in Understanding
Attainment Target 1: Understanding

Key Stage 1	Key Stage 2	Key Stage 3	Key Stage 4
make connections	describe and make comparisons	analyse	recognize affinity between and explain application and relevance
	experiment with methods of others and use	use knowledge to enrich own work	make use of others' methods in own work
identify examples	recognize difference for different purposes	compare work of others	identify work in context
describe and recognize different kinds	explain how others' work is influenced by time and place	recognize diverse ways others view and represent	evaluate critically and understand influences on meaning and interpretation

experience grows, pupils and their teachers will evolve ways of looking and talking about art from their natural enjoyment of it. Paragraph 3.25 says that 'Sensitive observation of the way pupils behave and learn will inform the care teachers take and the expectations they have'.

Another major concern is that of progress and continuity in art education. Taking the Key Stages together for each Attainment Target, it is possible to see how progress and continuity are conceived. When this is seen as a whole, it shows the different emphases that need to be placed on the way learning is managed so that progress between stages is achieved and continuity planned for.

For example, looking at Table 6.2, 'make connections' and 'describe and recognize different kinds' have to develop into 'describe and make comparisons' and 'explain how others' work is influenced by time and place' by the end of the primary years. These experiences, it is hoped, will lay the foundations for using, imaginatively, the methods and approaches of others in children's own work in the secondary phase. After the age of 11 it is hoped that pupils will move towards comparing, contrasting and evaluating the work of others.

Table 6.3
Pattern of Attainment Targets for a structured progression in the four Key Stages
Attainment Target 2: Making

Key Stage 1	Key Stage 2	Key Stage 3	Key Stage 4
experiment and work with	develop knowledge and experience; use tools and techniques experimentally and expressively	use range of techniques and media to realize ideas, express feelings and communicate meaning	explore ideas and meaning; use experimental approach
explore using a variety of methods	explore through experimenting		
experiment (with colour)	develop understanding (principles of colour); visual elements in making	identify and work with visual elements	use formal elements and visual conventions
explore and recreate			
explore shape, form and space; make 3D work	explore, apply and experiment with representing shape, form and space	explore and experiment for 3D work	demonstrate knowledge of 3D work
	plan and make 3D structures		
change scale working on own or in groups	work collaboratively to plan and make large and small work	develop understanding of large and small work, on own and in groups	refine knowledge and understanding
talk about work	use art vocabulary to explain	discuss work using vocabulary	use developed vocabulary and technical terms
modify work	adapt and modify work	modify and refine; discuss with others	develop the process of review and refinement
			draw conclusions and plan

Table 6.4
Pattern of Attainment Targets for a structured progression in the four Key Stages
Attainment Target 3: Investigating

Key Stage 1	Key Stage 2	Key Stage 3	Key Stage 4
record from direct experience	observe, select and record from direct experience; make connections between forms and ideas	develop specific skill for recording using a variety of media	develop skills associated with observation and recording; use and present effectively
respond to memory and imagination	use a variety of methods to respond use a sketchbook	keep a sketchbook	use sketchbooks and notebooks
make collections of images	assemble resources and experiment	explore and use a range of reference to establish an idea or theme	explore and use a wide range of reference
use resources	discuss use of references	discuss the purpose, method and application of their own research	use written and spoken language to describe methods, results and implications

Here, it is not just an increased sophistication of language and looking that is required but a different capacity to conceptualize and relate to the ideas of others. The work towards the Attainment Targets for art in the primary school is conceived as being part of this whole growth towards understanding art.

Curriculum continuity and progression are two aspects of art education which the National Curriculum wants to ensure (see Tables 6.3 and 6.4). *Art for Ages 5 to 14* (DES, 1991) states that

> Progression between two phases should be effective where pupils' previous experiences in art have been carefully structured with progression in mind and have been well documented.
>
> Good communication between schools will be crucial. . . .
>
> The introduction of the National Curriculum art will ensure common aims and consistency of practice across primary and secondary phases of education. (para. 3.10)

To summarize: it seems to me that the following five broad areas of concern are evident in the National Curriculum as it now stands. It would be sensible for primary school teachers to consider these and discuss them together. Some concerns might be more pertinent to their particular situation than others, but it does seem important to have views on the issues raised.

Major differences and concerns arising from National Curriculum: Art

1. Art involves more than just making; understanding and investigating are required aspects of art education from 5 to 14.
 Art is defined as art, craftwork and design.
 Pupils are expected to make changes and modify their work as it proceeds.
2. Pupils are expected to make their own collections of images and objects, working from direct experience and observation as well as memory and imagination.
 Pupils are expected to talk about and discuss the things they collect and use.
3. Pupils are expected to develop an understanding of art, craftwork and design, to describe, make comparisons, explain and use methods seen in the work of others.
 Pupils are expected to develop a suitable vocabulary to do this.
4. Curriculum continuity and progression, between classes and schools, are to be considered when planning the art curriculum.
5. Assessment of what pupils know, understand and can do should take account of the processes of working as well as the outcomes.
 The National Curriculum sets out agreed criteria for assessment. Pupils should be assessed against these criteria and not against each other.
 National Curriculum testing in art will be on the basis of teachers' own assessments.
 At the end of each Key Stage teachers should review their accumulated judgements in relation to the Attainment Targets. These assessments should be discussed with the pupil.

I will now consider these five areas of concern in more detail from the viewpoint of teaching in the primary school, using the teaching of painting as a paradigm for thinking about the issues raised in the National Curriculum as they affect art in primary schools.

1. ART INVOLVES UNDERSTANDING AND INVESTIGATING AS WELL AS MAKING.
ART INCLUDES CRAFT AND DESIGN; PUPILS ARE EXPECTED TO CHANGE AND
MODIFY THEIR MAKING AS IT PROCEEDS

For many years we became used to very young children working spontaneously with materials, and viewed the product of their endeavours with an open acceptance. Teaching young children techniques, or expecting them to conceptualize methods or plan processes, seemed to negate their spontaneous expression. In fact the practice generally seemed to be to leave children, especially young children, alone to enjoy their creative expression. The Working Group describe the weakness of this approach: 'A narrow range of activities has been dominant, centred almost entirely on "making" and accompanied by an uncritical reliance on pupils possessing instinctive powers of self-expression. Much has been undertaken in the past in the name of personal expressiveness which is neither personal nor expressive' (para. 3.4).

The approach to the creative experience of children which provokes this criticism is revealed in the way some teachers respond to children's paintings. That is, where some generalized, positive or noncommittal comment is made which reveals no knowledge or acknowledgement of what is special or of interest in the children's experience of painting. There would have been no careful observation of the process nor any attempt to discover what the children had intended or learned. Any comments would be casual and unsubstantiated as they would not be based on genuine observation or effort to share in the children's experience, and so they come across as dismissive of the discoveries, frustrations and satisfactions children may have experienced.

Very often the paint image that results from children being left alone with a large piece of poor-quality paper ('good enough for infants', as I have heard said), a thick, large brush and two or three yoghurt pots of brightly coloured, runny paint, expresses little more than the frustrations the children have encountered and the dominance of paint and gravity over the proceedings! The effect of this contact with painting for many children is frustrating and disturbing, as lumps of runny paint slide and smudge across the page, and the thick brush is totally inadequate to make any more than crude marks and clumsy mixtures of paint.

Evidence of this experience is seen on the walls of many classrooms: some pictures will appear lively and free but many will show the limitations and frustrations under which the children have had to paint. Generally, all the paintings will have a similarity, with large, thick and runny brush marks, crude colours merging or mixed together to give muddy shades, and very basic drawing.

Given the right materials, the possibility of mixing and some choice in

the size of brush, young children can mix colours, handle brushes with delicacy and show increasingly fine control of the tools and materials they use. Children who are encouraged to mix paint will soon enjoy it, become aware of differences in colour and texture of a painting's surface and be more alert to these qualities when confronted by original works of art, whether in the gallery or at school. If they are given the opportunity to work with fine tools and materials they will better distinguish fineness in the work of others: encouragement to increase the quality and range of their mark making with paint will enable them to read more readily the range of marks and textures in the work of artists. The exploration with paint achieved with 6-year-olds shows this approach, which was developed and extended with junior-aged children, as described in previous chapters and as illustrated in Plates 1, 2, 3, 4, 13 and 14.

It follows from this that where the teacher does not abandon children to manage painting on their own, but is an active observer of the process, the nature of the children's work and the teacher's understanding of it will change. Observing and discussing the process of making informs comments and discussion about the outcomes. The subtleties and changes discovered through careful observation during the act of handling the material are not lost but brought into focus as part of the learning, whether this is done at the time of observation or after the making.

It is because various things are noticed and used for discussion that an 'intelligence' about art making develops. No longer do the children have to contend with the uncertainties of the teacher's response. As we saw in Chapter 5, both teacher and children grow in awareness and understanding when rhetoric and closed questions are replaced by open questions and informed discussion based on mutual observation.

It is in the climate of increased sharing and a developing intelligence about the nature of paint and mark making with paint that children will grow in the confidence to 'implement simple changes' (Key Stage 1, Attainment Target 2).

It will become clear from the more interactive approach to children's creative work, rather than the directive or abandoned method, that there is more to achieving satisfaction from working with materials than just using them. There are all those facets of stimulating looking and the exploration of ideas as well as the experimentation with materials. Trying things out, seeing what might happen if . . ., being encouraged to extend looking; handling and investigating the appearance and structure of objects – all these activities begin to be part of the interaction of teacher and children, children and children.

As the work progresses, the discoveries, satisfactions aind frustrations generate a vocabulary as well as establishing and confirming existing areas

of knowledge between teacher and taught. Making connections, noticing examples from the surroundings to illustrate conversations and forming descriptions and explanations all grow naturally from this interactive learning.

Exploring mixtures and mark making with paint stimulates ways of handling it. Sequences and mixtures of colour, whether arrived at randomly or by some pre-selection by the child or teacher, can be related to ranges and harmonies and types of colour in the immediate environment.

The focus can shift to the textures and surfaces of paint, thus producing a whole new visual and painting vocabulary which builds on existing words and phrases. The introduction of artists' work can illustrate and affirm the qualities discovered in children's own explorations. The conversations this promotes about how artists have used paint may well lead to a curiosity about the form and design of their work and why they have used certain images. Children's curiosity about painting and what painting can do may be aroused through the link between their own experiences and ideas about paint and what they begin to see in the painting of artists.

It will be discovered that when teachers allow themselves sufficient time and space to observe the work children do, interaction with children becomes a natural part of the making process. Such interaction leads to greater understanding of the potential of art, craft and design. Furthermore, teachers who try to work this way will find that the conversations they have with children about their art will become easier, more constructive and informed.

It is hoped that this review shows that art is always more than making and how the attainment of understanding and investigating arise as part of the whole process. The kind of vocabulary and conversations teachers evolve with children will be different and more effective because they observe the process and do not rely solely on the product of children's making.

Lastly, there are many things that children experience with materials in a primary classroom which are not just art but also aspects of craft and design. A change of focus is required to see how these might fulfil children's understanding and investigations in the direction of craftwork or design.

2. PUPILS ARE EXPECTED TO MAKE THEIR OWN COLLECTIONS, WORK FROM THEM AND TALK ABOUT THEM

It will be noticed that Attainment Target 3b requires children to 'use a range of items *they have collected and organised* as a basis for their work' at Key Stage 1 and to 'assemble resources and experiment with ideas' and 'discuss their use of reference material in the development of ideas and themes' (at Key Stage 2).

It would be disastrous for a teacher, in order to fulfil this requirement, to stimulate every member of the class to bring in collections at the same

time; it would be equally irresponsible to ignore this requirement altogether. Many children enjoy collecting and having a cache of objects; their bedrooms will often display these, or pockets reveal them. However, the things young children like to collect are often not thought of as suitable for work at school.

If the interest in collecting is a natural one it can be developed in any number of ways, but especially if the teacher shows an interest in objects and collections through the displays which are set up in the classroom and school. It is not sufficient just to have things lying about, for they have to be shown off so that it looks as if someone cared for them and saw something of interest in them. For example, the silhouette of a plant against a window revealing its intricate shape suggests more than a casual interest in it; or pebbles placed on a piece of natural hessian reveal their subtlety of colour and form for others to notice; or an exotic object displayed on a piece of fine silk will be enhanced and given context in this way. Not only does the choice of position, lighting and background show off certain characteristics of the object, it shows the importance and particular value placed on it.

Prior to children bringing their own collections into school it is necessary to help them handle and discuss the objects that the teacher chooses and displays. This preparation will establish patterns of behaviour, purposes and approaches, so vital if the experience children have with their objects is to be a positive and productive one. These two things, the preparation through display and practice and the manner in which objects are handled and shared, create the ambience in which children will readily share their responses and ideas. Through conversation or more 'formal' discussion children will have their looking and handling of objects focused and be encouraged to commit themselves to particular points of view.

The approaches to working from collections will grow naturally from the way in which they are displayed, handled and discussed, and children are led into making their own displays and talking about them. Noticing differences, contrasts or similarities of shape, colour or function can form one starting point; enjoying the relative scale and context might be another. Imagining stories and making up associations, placing the objects in unusual lighting or relationships might be others. One has to remember that children are used to handling all sorts of things by the time they come to school. The skill is to direct and focus their looking in order to extend it.

There has to be an understanding not only of how objects and collections are stored and displayed but especially of what kinds of attitude one hopes to inculcate and encourage for handling any items brought into the class, particularly very personal or valuable ones. I will make a few simple observations about how this requirement is more likely to succeed. It is the teacher who exemplifies and controls the way objects are received and handled.

The way hands are used can reveal a great deal: using fingers to caress,

delicately poise or touch rather than grasp; the palms can be open and receiving and also show off and present objects, however small or mundane. The speed with which actions are taken, objects are handled and placed, matters. Should there be lots of objects, the manner of placing them together, categorizing or grouping them on a prepared surface will amplify their qualities and focus the children's attention and discussion in new ways. How objects are treated and shown off can be the source of comment, question, discussion and ideas.

These considerations will show children how to touch and place objects and that even the most everyday and ordinary things can be displayed to reveal new aspects: for example the shine of windows in a cup or spoon, the change of colour in the same type of leaves when the light shines through them.

Once care has been taken in receiving and handling objects the time and space for doing this can fall naturally within the work pattern of a day or week. The activity can become a moment of calm reflection in the diverse busyness of the class, or a point of stimulation for new ideas and thoughts to enter the work.

Talking about observations, discussing ideas and focusing on looking is a significant part of many of the National Curriculum subjects. Integrated and cross-curricular ideas and starting points arise from this activity and are confirmed by it. It is an aspect of a teacher's work which is well worth the effort to cultivate. Such sharing can entice language from a group, suggest new directions for work, relate individuals' own experiences and knowledge to that of others, and so on. In a group of thirty there are thirty pairs of eyes, thirty different minds with their sensibilities, experiences and imaginations. All this potential can be brought to bear in the well-managed discussion/ sharing group.

Many primary school teachers are, of course, well used to this kind of group sharing when stories are read at the end of the day. It is the extension of this idea that is suggested, where there is much more than listening required of the children.

Working with objects and collections need not be daunting or time consuming, for, throughout the term and the year, every child can have the opportunity to bring into the class their own collections as ways of storing, displaying and handling them are evolved to suit the pattern of the day and the manner of the teacher's approach. The pattern of activity suggested here will lead naturally to children wanting to paint from the collections and encourage them to develop both the visual and verbal vocabulary to paint from and talk about the collected items.

3. PUPILS ARE EXPECTED TO DEVELOP AN UNDERSTANDING OF ART, CRAFT AND DESIGN; TO DESCRIBE AND MAKE CONNECTIONS AND COMPARISONS WITH THE WORK OF OTHERS, EXPLAIN WHAT IS SEEN, AND EXPERIMENT WITH METHODS

Developing an understanding in art grows along with the two areas already discussed. The demands of looking and the vocabulary required to communicate what is seen obviously should include looking at the work of artists, craftworkers and designers. The way responses and the imagination can be stirred through enjoying objects leads to wondering about the intentions of artists, the choices they make and the context in which they work. Questions about the artists' and designers' selection and use of materials and processes might form a starting point for work, or again the specific qualities of the thing produced: its surface and colour, solidity (form) and texture; or again the exploitation of the qualities of specific materials by craftworkers. The teacher and children together can devise and evolve ways of awakening ideas, focusing interest and seeking out parallels in their own and others' work.

Approaches to working with art and artists, the forms and images, processes and approaches they use, are carefully described and illustrated in *Educating for Art* (1986) by Rod Taylor. This book considers resources such as museums, galleries and art centres, regional art groups, the work of artists in schools and the use of loan collections.

The requirements of the National Curriculum Art expect children to 'make connections between their own work and that of others, including artists, craftworkers and designers'. This Attainment Target suggests that the teacher needs to make some selection of appropriate pieces of work to facilitate the making of 'connections'. This need not be an arduous requirement to fulfil, as local galleries and museums, local artists, craftworkers and designers are often interested and willing to share their objects with children. If these sources of original work fail, and teachers do not feel confident about any pieces they may have personally, students from a local art school, sixth-form college or secondary school can be a source of pieces of original work to share with children.

One cannot predict what children will derive from looking at the work of others, or how they might acquire and assimilate fresh ideas from them. The conversations children and their teachers will have about painting will, inevitably, become more informed, searching and supported by the practice of sharing the work of others. The teacher does not have to provide quantities of gratuitous technical, historical and biographical information before children can be exposed to original works of art; the need for such material may grow as children seek more from the work. The teacher should never feel ignorant or lost for he or she is, properly, party to the shared looking,

exploration and discoveries. Learning where and how to find answers is more important, educationally, than just being supplied with unrelated facts.

Once the sharing of work by artists, craftworkers and designers has started, teachers will soon find that their knowledge and understanding is increasing and will enjoy sharing this with children. What is found out about processes, and the background to artists' lives, ideas and ways of working, will be used with subtlety to excite further interest and indicate new paths to follow.

4. CURRICULUM CONTINUITY AND PROGRESSION ARE TO BE CONSIDERED

We have already seen how curriculum continuity and progression are conceived between each of the Key Stages for the three Attainment Targets in the simplified matrices (Tables 6.1 to 6.4). In paragraph 3.10 a number of claims are made about the purpose and likely effect of these requirements, particularly in regard to primary/secondary school transition: 'The National Curriculum will ensure common aims and consistency of practice across primary and secondary phases of education.'

Presumably, schools would not focus solely on this point of change in children's schooling but would have some positive view of how learning might progress prior to and following this break and how the curriculum might be planned and taught to promote continuity.

The National Curriculum document (DES, 1991) seems most concerned about the transition between primary and secondary schools, however, and suggests a number of actions that schools and local education authorities (LEAs) should take to ease this transition. In paragraph 3.10 it states that 'Progression should be effective where pupils' experiences in art have been carefully structured with progression in mind and have been well documented.'

Workshops, exhibitions, sharing resources, in-service sessions and discussion groups are suggested as ways to improve communication and continuity between primary and secondary schools.

Bearing these strictures in mind, it makes sense for the staff of each school to devise their own propositions about what progression means in terms of their approach and ideas, based on the criteria of the National Curriculum, and to determine how continuity might be achieved within this pattern. Primary schools need to be clear in their understanding of continuity and progression if they are to enter discussion with secondary colleagues in a positive and supportive manner.

The advantages of such staff discussions are that

- they set the thinking for and give a pattern to curriculum discussions in all subjects;

- they help everyone to interpret the statements of the National Curriculum and relate them to their practice ('Oh! that's what the words mean');
- they will suggest points of cross-fertilization and collaboration between subjects and teachers ('I get children to do that in science');
- they will reveal where resources can be shared, can act as a common stimulus, or have potential to support aspects of the curriculum not previously considered ('I had never thought of using . . . but I can see the possibilities now that we've discussed it');
- they will encourage staff to realize that not everything has to be tackled by everyone but that amongst any group of teachers and ancillaries there is a range of expertise, knowledge, experience and understanding to be called upon.

To expand these points in a little more detail, the question might arise about progress in pupils' painting and what elements of continuity to look for in its development.

Someone might suggest that the group look at what the document says. It would be found that children have to work with a 'limited range of tools and materials to explore basic aspects.' Exploring basic aspects through a limited range is as important a starting place for painting as it is for other subjects, especially when this statement is linked with other statements in the National Curriculum about the early stages of learning, such as making 'simple changes, recording images and ideas from direct observation and collecting and organising a range of items, and talking about what they have done.'

For example, in a painting session simple objects will be collected and introduced to the children, who are to paint through touching, holding, talking and sharing, as suggested in earlier chapters. Other children may also take part in this session but use the same objects for different learning (for example drawing, weighing and measuring) or for writing, the sophistication of the tasks depending on the age of the children. This approach takes time initially but helps to register some of the painterly qualities of the objects with the children, such as the changes of colour and surface, the weight and form of the shapes, and leads the children through conversation and experience into the work (painting).

It might be realized that this approach to teaching is followed by other members of the staff when handling different areas of the curriculum. They see the connection between this approach to painting and their own teaching, and recognize that it helps to guide children towards making changes in their thinking and observation where time has been allowed for sharing

objects and developing conversations about them. One teacher might point out that he or she starts simple science sessions like this, while another may speak of language work through 'finding' children's words for everyone to enjoy before individual pieces of writing are attempted.

What sorts of thing are collected and how they might be used so that progression might be seen in the way children handle objects is questioned next, leading to comments about objects that some teachers have used in special ways that hadn't occurred to others. The use of these objects, let's say tools and equipment from the kitchen, garden or workshop, and playthings, can be added to by several members of the group. It is seen that this collection can be used not only for work in different areas of the curriculum and to satisfy similar Attainment Targets, but also with children of different ages.

The teachers' experience tells them the kinds of things to look for as the objects are handled by children of different ages. Very young children make direct, sensory connections with the objects, enjoying or rejecting their sensory qualities: their hardness or softness, weight, temperature, surface and texture, general shape and configuration and so on. Simple words might arise through the handling which do not necessarily describe accurately the object but convey the sensations it creates. (For example, a 6-year-old referred to a piece of coral as looking like tissue paper.) Paintings that arise from these experiences will convey simple features in broad shapes and a range of colour depending on the opportunity for and skill at mixing.

Older children will question the function of the object, make comparisons with concepts they already have of things they have seen or about which they have read. They are more likely to want to try things out and even invent things with the objects. Their questions will search into the construction and technology behind the objects and their perceptions about the shape and configuration of the objects, as seen in their paintings, will be more concerned with the proportions and arrangements, colours and textures, even if they move into fantasy to describe their possible or imagined purpose.

During the discussions, different members of staff will realize that they have complementary or additional experiences to contribute. Two other important elements of teaching will grow from these exchanges, which should become part of the staff proposition. First is the kinds of words and language with which to talk about what they have done and hope to do with children of different ages. This language will evolve from their interpretation of the National Curriculum documents and be developed with children as they teach. In the hands of teachers, conversations can reveal possibilities across subject boundaries as well as special words for particular subjects.

Secondly, teachers will recognize that a shared vocabulary is vital to making any statements about children's work in order that progress between what is taught and learned can be noted. How can one teacher understand what has happened if there is no evolved and shared vocabulary with which to communicate it? Samples of children's work alone will not be enough to explain what they have learned.

Of course, it is only possible to suggest here how such exchanges might proceed and what topics might be covered in developing any proposition about progression and continuity, but I hope that sufficient has been said to show the possibilities for staff discussion to release ideas, experience, knowledge and resources.

It is from these exchanges that propositions about progression, what kinds of things to look for at different stages, can be attempted which everyone can understand. Guided by the National Curriculum statements, such propositions can relate to the criteria which are in the National Curriculum, but more importantly from the point of view of actual practice, they can form the basis for understanding children's learning across the range of subjects and show the common ground between them.

There is much common ground to be explored in the early stages of children's learning, especially if teachers realize that an interactive approach is demanded rather than a prescriptive or didactic one (see Chapter 5, 'The Role and Approach of the Teacher').

The pattern of curriculum discussion can start with a review of the particular criteria for a given Attainment Target, to which others can add their reading of Attainment Targets for other subjects which they feel have a similar thrust. The way these targets are interpreted by the staff group will include ideas and experiences they have already of working in that school and area with those particular children.

Points of collaboration and cross-fertilization will develop as different staff suggest correlations between what is required from the Programmes of Study of different subjects. Discussion about the resources available to support the ideas that emerge will suggest how, in practice, the Attainment Targets might be achieved.

All of these matters can be incorporated in the propositions staff draw up to determine progression and continuity.

5. THE ASSESSMENT OF WHAT PUPILS KNOW, UNDERSTAND AND CAN DO WILL
BE THROUGH THE NATIONAL CURRICULUM CRITERIA. ASSESSMENT AT EACH
KEY STAGE WILL INVOLVE TEACHERS REVIEWING THEIR ACCUMULATED
JUDGEMENTS AND THOSE OF PREVIOUS TEACHERS

The assessment of children's artwork in the context of the approach of
this book will be explored in Chapter 8. This section will address itself to
the demands and expectations of assessment as the National Curriculum
sets them out and as they may concern primary teachers.

At the outset it must be made clear that it will no longer be correct or
sufficient to judge one child's art against others, stating such preferences
by selecting some pieces for personal accolade, display or ranking against
others. The point is made clear: 'National Curriculum procedures favour
assessment by the application of criteria intended to reveal the quality of
each pupil's performance irrespective of the performance of other pupils'
(DES, 1991, para. 8.4).

Of course, the habits of a lifetime will not be changed by a few words;
there has to be a change in the ideas that inform assessment and the under-
standing people have of its purpose before attitudes towards it change
customary practice. It is the simplest thing in the world to slip into comparing
and ranking children's work, and for many primary teachers with little or
no art training, and therefore no criteria to use beyond personal judgement,
this is the way assessment in art has frequently been done.

Now, however, there are criteria, drawn from the National Curriculum
document, which every teacher will be expected to know and begin to use:
'Pupils' achievements are assessed against given criteria which may be
derived from our recommendations for the attainment targets, programmes
of study and statements of attainment' (para. 8.4).

Where the Programmes of Study state that pupils 'should show', teachers
will have to ask, of themselves and collectively with their colleagues, Can
pupils . . .?; Are pupils able to . . .? Can this pupil . . .?; Is this pupil
able to . . .? The answers will relate the pupil's achievement to one or
more of the statements on the Attainment Targets or Programmes of Study,
not to what other pupils may or may not have done.

Furthermore, the answers to questions about pupils' achievement should
be derived from observing and knowing about the processes pupils go
through in order to achieve an end product and not by gathering their
work together at the end of a session and making comparative judgements
about it through considering results alone. Paragraph 8.10 states that 'When
assessing achievements in art, it is important to balance the relationship
between the quality of an end product and the process of its making.'

Added to this, the three Attainment Targets are set out in such a way

that it makes assessment of children's artwork by considering the results alone virtually impossible. How children begin to understand the meanings and purposes of art and the way they investigate the procedures, language and materials of art making are integral to the notion of being educated in art which is put forward by the National Curriculum. To give an example in the language of the document, as well as assessing whether children can 'experiment with the use of mixing colours from primary pigments' (Key Stage 1, AT2: Making) they should also 'make connections between their own work and that of others' (Key Stage 1, AT1: Understanding), and 'record observations from direct experience of the natural and made environment' (Key Stage 1, AT3: Investigating).

How teachers come to understand and approach teaching art will have to be extended beyond merely providing materials and judging the results. But this is not difficult or out of the way for primary teachers who have been concerned to talk with children about their learning; who help children observe and investigate the world around them and talk about their discoveries; who find ways to share how children learn as well as what they learn and use the results children achieve to reflect on and extend their understanding. This approach does not apply just to art teaching, but in art teaching it is crucial.

Testing in art education will be on the basis of teachers' assessments, and these should take into account the processes of working as well as the results, the way work has grown and developed (formative assessment) as well as the sum of these efforts in end products (summative assessment). To be able to review accumulated judgements at Key Stages teachers will help each other if they have noted down something about each child's work and approach as well as kept a number of pieces of work. Further comments about the kinds of notes and comments will be found in Chapter 8.

This review of the requirements, recommendations and implications of the National Curriculum art document is intended to give primary teachers support in reading it with confidence. It is hoped that those who read this review will recognize that much of the intelligence about children's learning which has been built up over recent decades is embedded in it and that the extensions to practice, in such things as assessment and understanding art, craft and design, will be developed through existing thoughtful, planned and perceptive teaching.

Table 6.5
End of Key Stage statements

	Key Stage 1	Key Stage 2	Key Stage 3	Key Stage 4
AT1 Understanding	*Pupils should have demonstrated that they can*			
Pupils should be able to evaluate and use practically and imaginatively in their own work the approaches of other artists, craftworkers and designers working in diverse contemporary and historical cultures and contexts.	(a) begin to make connections between their own work and that of others, including artists, craftworkers and designers; (b) recognize that there are different types of art, craft and design.	(a) use imaginatively comparisons between the work of other artists, craftworkers and designers in order to inform their own work; (b) recognize how the work of artists, craftworkers and designers is influenced by the different cultures, contexts and times within which they work.	(a) use imaginatively in their own work and in the presentation of their ideas and feelings an understanding of some of the methods and approaches employed by other artists, craftworkers and designers; (b) compare, contrast and evaluate the work of artists, craftworkers and designers and recognize that images, symbols and objects are influenced by diverse cultural and social conventions.	(a) incorporate an understanding of the specific methods and approaches; (b) explore the work of artists, craftworkers and designers from a variety of cultures and contexts, wherever possible at first hand; place the work in historical context and understand how its value and meaning is subject to different interpretation.

Table 6.5 cont.

AT2 Making	Key Stage 1	Key Stage 2	Key Stage 3	Key Stage 4
		Pupils should have demonstrated that they can		
Pupils should be able to use the skills and knowledge involved in the process of making (including the ability to select and control the use of materials, tools and techniques and an understanding of the visual language of art, craft and design) and apply these in their own work to develop, express and modify their ideas, intentions and feelings.	(a) work practically and imaginatively with a limited range of materials and tools and explore basic aspects of the visual language of art, craft and design; work individually and in groups to make large- and small-scale work in two and three dimensions;	(a) apply a basic grasp of the visual language of art, craft and design and of the variety of technical and expressive outcomes that can be achieved when a range of materials and tools are used; work individually and in groups to make large- and small-scale work in two and three dimensions and, where practicable, in time-based work;	(a) apply a broad knowledge of the visual language of art, craft and design; experimenting with a broad range of media and use appropriate materials, tools and techniques purposefully in the implementation of their ideas;	(a) use their knowledge and understanding of the skills and processes of making to express their feelings and ideas fluently and imaginatively in their work;
	(b) implement simple changes in their work in the light of progress made.	(b) modify their work in the light of their intentions, the choices involved in the making process and the results.	(b) modify their work as it progresses, reviewing its development and meaning in the light of initial ideas.	(b) plan and make further developments in the light of their discussions about the progress and meaning of their work and their own informed judgements.

Table 6.5 *cont.*

	Key Stage 1	Key Stage 2	Key Stage 3	Key Stage 4
AT3 Investigation	*Pupils should have demonstrated that they can*			
Pupils should be able to develop their visual perception, recording from direct observation, memory and the imagination and visualize ideas drawing on a wide range of resources which they have selected from the natural and man-made environment.	(a) record images and ideas from direct observation, memory and the imagination; (b) use a range of items they have collected and organized as a basis for their work and talk about what they have done.	(a) select and record images and ideas from direct observation, memory and the imagination, using a range of materials and methods; (b) prepare and develop an idea or theme for their work by collecting and organizing visual and other resources; discuss their methods.	(a) use a variety of methods to record and present their observations and perceptions from direct experience, memory and the imagination; (b) develop a chosen idea or theme by exploring a range of visual and other sources; discuss the method and result of their investigation.	(a) develop their methods of recording visually from direct experience, memory and the imagination to explore, interpret and present their ideas; (b) inform the development of personal work by drawing on a wide range of visual and other sources; discuss the methods, results and implication of their research.

Table 6.5 *cont.*

	Key Stage 1	Key Stage 2	Key Stage 3	Key Stage 4
AT1 Understanding	make connections between; recognize differences	use comparisons to inform; recognize influence of differences	use methods and approaches of others; compare, contrast and evaluate	incorporate an understanding; explore and place in context; understand value and meaning of different interpretations
AT2 Making	(a) work with a limited range; explore basic aspects (b) implement simple changes	(a) apply basic visual language and range of materials and tools (b) modify work	(a) apply broad knowledge of visual language; experiment with broad range to implement their ideas (b) modify work; review development and meaning	(a) use knowledge and understanding to implement (b) plan and make further developments; discuss progress and meaning of work and judgements made
AT3 Investigation	record; use a range of items; talk about	select and record; use a range of materials and methods; prepare and develop; discuss methods	use a variety of methods; record and present; develop chosen idea by exploring a range; discuss method and result	develop recording methods to explore, interpret and present; inform development

Appendix: Developments and alterations to the National Curriculum

During the course of this book's completion and the reading of the proofs, the Minister has rejected the proposal of the Art Working Group to have three Attainment Targets for Art, namely: AT1 Understanding; AT2 Making; and AT3 Investigating.

In response to my letter of 23 January 1992, the Department of Education and Science stated that:

> The Secretary of State has accepted the NCC's advice for a two attainment target structure because he considers that this provides a better framework for the planning and assessment of pupils' work in art, will be simpler to understand, and more manageable in the classroom.
>
> The Secretary of State agrees with the NCC, and with the Art Working Group, that there should be a practical emphasis in the teaching and learning of the subject. He therefore proposes that more attention should be given to Investigating and Making (the proposed AT1) than to Knowledge and Understanding (the proposed AT2). Subject to the results of the consultation exercise, he has it in mind, when the time comes to make Assessment Orders for art, that the proposed Attainment Targets should be weighted at about 2:1 in favour of the first target.

The provisions of this order relating to the first Key Stage came into force on 1 August 1992 and take effect on 1 August 1993 for all other pupils.

The changes to the Attainment Targets, when studied closely, reveal that there has been a shift from experiential learning to knowledge-based learning, although there is an increased emphasis on practical experience. For example, the end of Key Stage statements reveal this shift.

> *August 1991*: Pupils should be able to evaluate and use practically and imaginatively in their own work the approaches of other artists, craftworkers and designers working in diverse contemporary and historical cultures and contexts. (AT1 Understanding)

> *August 1992*: The development of visual literacy and knowledge and understanding of art, craft and design including the history of art, our diverse artistic heritage and a variety of other artistic traditions, together with the ability to make practical connections between this and pupils' own work. (AT2 Knowledge and Understanding)

These differences are registered in the subsequent Programmes of Study:

1991: Respond practically and imaginatively. . . . Explore art, craft and design in a wide historical and cultural context. (AT1)

1992: Recognise and identify the differences in various kinds of art. Respond to art from a variety of styles, times and cultures. Begin to make connections between their own work and that of other artists. (AT2)

Recognizing and identifying, responding to styles and *making connections* are things which can be learned by telling and remembering, though in the hands of experienced and thoughtful teachers this would not be the approach. *Practical, imaginative response and exploration* demand active participation.

August 1991: Pupils should be able to use the skills and knowledge involved in the process of making (including the ability to select and control the use of materials, tools and techniques and an understanding of the visual language of art, craft and design) and apply these in their own work to develop, express and modify their ideas, intentions and feelings. (AT2 Making)

Pupils should be able to develop their visual perception, recording from direct observation, memory and the imagination and visualise ideas drawing on a wide range of resources which they have selected from the natural and man-made environment. (AT3 Investigating)

August 1992: The development of visual perception and the skill associated with investigating and making in art, craft and design. (AT1 Investigating and Making)

The differences are, once again, registered in the programmes of study:

1991: Develop skills and express ideas, feelings and meanings by working with materials, tools and techniques and the visual language of art, craft and design. Review and modify work in relation to intentions. (AT2 Making)

Observe and record, make connections and form ideas by working from direct experience, memory and the imagination to develop visual perception. Visualise ideas by collecting and using a wide range of reference materials. (AT3 Investigating)

1992: Represent in visual form what they observe, remember and imagine. Use a range of items they have collected and organised as a basis for their work and talk about what they have done. Work practically and imaginatively with a variety of materials and methods exploring the elements of art and design. (AT1 Investigating and Making)

Success at *representing in visual form* could be viewed as copying or striving for

exactness and is of a different order from *developing skills and expressing ideas, feelings and meanings.*

There does seem less deviance from the spirit of learning through experience in *working practically and imaginatively exploring the elements of art and design.* However, *observing and recording, making connections and forming ideas from direct experience* seems a more direct way of engaging in investigation than just handling the elements of art and design.

It appears as though the Minister could not believe that knowledge about art would be acquired from the Programmes of Study as set out. Hence, subtle and sometimes more obvious changes can be discerned throughout the redrafted document, shifting the emphasis from learning through direct experience towards knowing by being told, with all this implies for the planning and support of children's creative work.

Despite my reservations, as set out above, the National Curriculum Draft Order for Art does place discussion of the practical activity of art, craft and design firmly on the school agenda. The broad areas of concern for schools and teachers to consider, which are set out in this chapter, remain as relevant now as before.

The broad matrix of the revised National Curriculum for Art 1992, as it affects primary schools, derived from the end of Key Stage statements is shown in Table 6.A1.

Table 6.A1

	Key Stage 1	*Key Stage 2*
AT1 Investigating and Making	*Pupils should have demonstrated that they can*	
	(a) represent in visual form what they observe, remember and imagine;	(a) communicate ideas and feelings in visual form based on what they observe, remember and imagine;
	(b) use a range of items they have collected and organized as a basis for their work and talk about what they have done;	(b) develop an idea or theme for their work, drawing on visual and other sources, and discuss their methods;
	(c) work practically and imaginatively with a variety of materials and methods exploring the elements of art and design;	(c) experiment with and apply their knowledge of the elements of art and design, choosing appropriate media;

Table 6.A1 *cont.*

	Key Stage 1	*Key Stage 2*
AT1 Investigating and Making	*Pupils should have demonstrated that they can*	
	(d) implement simple changes in their work in the light of progress made.	(d) modify their work in the light of its development and their original intentions.
AT2 Knowledge and Understanding	*Pupils should have demonstrated that they can*	
	(a) recognize and identify the differences in various kinds of art; (b) respond to art from a variety of styles, times and cultures; (c) begin to make connections between their own work and that of other artists.	(a) recognize the influence of different cultures and contexts and apply a developing knowledge of art; (b) talk about works of art, relating them to their historical contexts; (c) make imaginative use in their own work of a developing knowledge of the work of other artists.

CHAPTER 7
Classrooms Right for Painting

Classrooms come in many sizes, shapes and configurations. Whether a classroom is a temporary wooden box or a massive Victorian hall with a high ceiling and windowsills, it is a space over which, traditionally, a teacher has a large measure of control. It is a space to which, day after day and in many cases year after year, an adult will return to work with a group of children. This, alone, should be sufficient reason to make it as good a working environment as possible.

Many of the physical environments in which teachers work cannot be altered and are difficult to modify; some are uncomfortable and not conducive to achieving high-quality work. While many will make the best of the situations in which they find themselves others, perhaps with just cause, will protest against their surroundings. The thrust of the comments in this chapter is to consider those aspects of classrooms over which teachers do have some control. It is clearly recognized that there are many things about classroom environments which make a teacher's job much easier, such as good natural and artificial lighting, clean and fresh decoration and display and proper storage and sink facilities. Many would consider these things absolute necessities but where they do not exist there is evidence that teachers can still provide stimulating and well-organized opportunities for their pupils to learn.

This chapter takes account of the many teachers not fortunate enough to experience all the ideal physical and human conditions when setting out guiding principles and the suggestions that arise from them.

The first suggestion is that, in whatever kind of space a teacher works, he or she should spend a little time observing the movement of the children around it. This will reveal those areas which are quiet while others are very busy; which parts of the space are under pressure and which badly utilized; where congestion takes place and resources are inaccessible, and so on. The points of the room-space which attract the most attention will be seen, some of which are obvious, others not. Doors, sinks, windows, cupboards, depending on what is in them, and shelves, are all likely points of focus. Movement to, from and around these points of focus matters when thinking of setting up and allowing practical activity, especially when materials that have the potential to create a mess are involved. Bearing these points in mind, what kinds of assumption can be made about the requirements for painting?

1. There must be a source of *water*. If the room has no source of water this is the first difficulty to be overcome, for painting requires water as a medium and a cleaning agent. Fresh, clean water is needed and also a means of disposing of dirty water. If there is no sink, two or three buckets will enable the painting activity to go on. These should stand on a plastic sheet somewhere near the door, which saves spillage across the room. The plastic sheet identifies the 'wet' area, which can be further delineated by battens of wood under the plastic sheet to create a ridge to hold in any spilt water.

2. The tables/desks, easels and stands that are set aside for painting should be in close proximity to the 'wet' area and can help to define it. A further table or bench can be set aside for paints and painting materials so that they may be laid out neatly and kept in good order, and are always ready for use.

3. Whether the room has a sink or bucket area, the following comments apply. One should be prepared for and not alarmed by accidents with water. Even the most motivated children can spill or tip water. Locating painting near a wet area and with ease of access to the door, or by a sink, limits the effects of such spillage as water is carried to and fro. A supply of mopping-up cloths is as good a precaution as patience and understanding.

4. A space to set out the trays of colours is necessary, where they can be refilled and stacked. The order and cleanliness of this area is very important as it sets the standards and determines how children acquire and maintain the right approach to their own painting. Mucky paints, dirty brushes and an untidy wet area are sufficient to put anyone off painting and almost ensure untidy and dirty work practices. In some cases, stackable plastic carrying crates can be used for storing and keeping together the materials for different art, craft or design activities. These can be lifted out easily when stored in cupboards on or under side benches, and can be shared amongst a group of classes, where, say, the particular tools and materials for three-dimensional design work would be available at different times to more pupils. A trolley set out with materials can fulfil a similar purpose and keep things tidy.

 The containers of powder colour can be devised from plastic caps or cartons about two inches in diameter and one and a half inches deep. Having sufficient of these ensures that colours can be replaced and kept fresh. If these pots are contained in a plastic box the possibility of spillage is reduced almost completely. Large containers of powder colour for replenishing pots can be kept near

the 'wet area' if the teacher is confident that the pupils are able to refill pots themselves or with the teacher's minimal help. Otherwise, these containers should be in a separate place for use by the teacher alone.

5. The range of colours should be limited and of the same manufacture of colour, and once chosen, should be used all the time. This enables children to understand how particular colours behave and to become familiar with the way mixing can be developed. A basic palette of the primary colours plus black and white will enable considerable colour discoveries to be made without resorting to a cupboard full of all sorts of strange colours and the complexity of ordering and storing this poses. As has been suggested, two reds are required, one crimson and one vermilion, so that good purples and oranges respectively can be achieved. Yellow ochre, umber brown and viridian green could be added at some point to extend the palette, but these are not essential.

Working with such a limited range of known colours has considerable advantage for the teacher. There are fewer tins of colour to control in storage and ordering. It is easier to see how much skill and sensitivity children are developing in their mixing as one becomes familiar with the range and types of colour possible from an established palette. It is easier to achieve a balance between strong and weak colours when restocking, as one needs three or four times the amount of white and yellow to colours like red and blue.

A cursory examination of school stock cupboards often reveals tins and tins of unused and unwanted colours: several different blues and reds, purples, greens and orange. The cost and time expended on all these could have been used for the supply of the basic palette, thus saving time, cost and frustration. The comments in Chapter 1 should be noted.

6. A selection of brushes is essential, whatever age the children. Large round and flat-shaped brushes are standard, to which should be added smaller brushes and especially watercolour brushes. These can be of nylon, which is durable and reasonably priced. Children soon learn how to take care of brushes, especially if there is a place for them to be stored, bristle uppermost, and if they are helped to understand what can damage them, for example being left too long, bristle down, in water or hardened with adhesive.

Other tools which can be offered include plastic palette knives and spreaders, sponges, rags and sticks, cane and small blocks or pieces of wood. Mark-making materials of various kinds can be stored in shoe boxes and available for special developments in

paint handling, such as printing, or on request for the particular purposes of individual pupils.

7. A selection of papers should be offered so that children can be aware of the varied effects that different surfaces have on the way paint handles. Some papers, like sugar papers, are very absorbent and inhibit the running of paint but are sufficiently thick to enable the paint surface to be built up. Apart from absorbency, papers have other obvious qualities such as surface texture and colour. White paper does not always have the best surface for painting, some types being shiny and hard and others breaking down or rucking up when wet. Cartridge paper, which comes in different weights, is suitable for painting but tends to be expensive. Newsprint, kitchen paper and the like are only sufficient for activities such as printing and taking rubbings. It is wrong to think that these thin, poor-quality papers are 'good enough' for infants.

As well as the papers already mentioned, it is worth exploring packing papers of different kinds, including brown papers and card. Board and card can be whitened with emulson paint and give a strong, pleasant and sometimes rigid surface on which to paint.

Any second-hand paper should be trimmed to rectangular shapes and be clean, flat and free of creases. A short time spent selecting and preparing such paper pays handsomely when encouraging pupils to be discriminating, and when displaying their work later.

8. A place to store and protect paper is essential, whether this is in the classroom or elsewhere. A deep cupboard or shelf is suitable or, failing this, a strong cardboard box, wide and long enough for full sheets of paper but not too deep. Presenting paper with trimmed edges and right-angled corners is important. It may be necessary, every so often, to prepare a stack of pieces of paper using a cutter, but once this is done, the business of mounting and displaying completed work is easy. It makes infinitely more work for a teacher to have to trim and straighten children's work after they have completed it.

9. Other materials and apparatus might be added which would increase the ease and enjoyment of handling paint, for example mixing trays or large tin lids, sponges and rags.

10. There should be some place to leave paintings to dry, whether this is on the paint tables, on a side bench, pinned to a board or hanging on a 'clothes line'. It is difficult to conceive anything more disheartening for children than to see their precious paintings stuck together or trodden on, torn and creased. Once dry, the results of

any session should not be discarded but used to form the basis for further learning and reflection.

It is worth adding a general caution at this point. It seems to me that it is sensible, especially from the point of view of organization and storage, to develop work in art, craft and design by planning deliberate extensions to a limited range of basic materials. Taking on too many different materials and consequent processes in a haphazard, perhaps opportunistic way, can lead to superficial work, storage and management problems and frustration for teacher and pupils alike.

It makes more sense to extend the variety and range of pupils' ideas and the sources of stimuli for these than to keep introducing new or different materials and things to do. Pupils need time, opportunity and practice with a few well-chosen materials and media in order to begin to handle them with ease, familiarity and confidence.

This caution applies especially to taking on materials which may require tools and the correct adhesive to shape and join them: cardboard boxes stuck with cold-water paste or wood split with nails are recipes for disaster.

Certain basic materials, for example drawing materials, will have a general use across art, craft and design and enable learning in each of these areas. To develop experience in three dimensions or fabric will require extensions to storage and the means to handle them. These are best thought through and planned if they are to be successful.

A basic range of materials is discussed in *Children and Art Teaching* (Gentle, 1985), where suggestions are made for categorizing and choosing a range of basic materials noting their characteristics and possibilities. Amongst all the materials that can be offered to children paint must be one of the most exciting because of its versatility and ease of handling.

Apart from these general considerations, the propositions of the National Curriculum for art, craft and design presuppose a careful review of the materials, tools and media held by each school to enable them to provide for the range of work suggested.

Storage of materials

The pressures of a busy school day and the apparent speed with which weeks pass by too often do not allow time to really organize storage. Yet this is one of the actions which can save an enormous amount of time and energy and be significant in the way pupils manage their learning. So at some point it is worthwhile addressing the topic of storage in one's own teaching space.

When I have done this with a teacher the approach we have taken is to clear everything from an area at a time or even move everything to the centre of

the classroom. It is then possible to see the potential storage space freshly and to clear out everything that is seldom (never) used, the dirty, tatty materials, equipment and books, the unused extra powder colour and so on. Boxes for specific storage can be acquired, covered and clearly labelled, especially where it is intended that pupils should have access to them. Even if it is only the visible end of storage boxes which is covered and labelled, this makes an enormous difference to the appearance of the room.

Consideration can be given to the siting of specific things, such as paint, water pots and similar items near the sink or door. The teacher can visualize how different spaces, shelves and cupboards might be used, how often they might be visited and by whom. Such considerations become important as the room fills up with busy children!

Some items, such as books or boxes, may require greater protection if they are to be handled frequently; these should be covered with plastic film. Decisions should be taken as to which are stock items and which need to be accessible every day. Some of the former might be stored outside the classroom. Anything unlikely to be used should be discarded.

The compact and organized storage of materials may take an initial effort to achieve but pays dividends: for example in spending wisely in the knowledge of what one has and needs to add to it; in peace of mind in planning, preparing and developing work with children and in establishing a calm, ordered approach to children's learning.

Good storage has two important functions:

- to keep materials in good order, clean, tidy, safe and ready for use;
- to enable materials to be retrieved and returned easily by teacher or, where appropriate, pupils.

As far as possible windowsills should be left clear of any storage; tops of cupboards also, as the sightlines, when glancing around the room, should be near level and not broken by clutter. It is surprising how the appearance of a room can be transformed by attention to certain details, such as

- keeping sightlines as level and uncluttered as possible, whether they are made up from cupboards, shelves or displays;
- displaying posters, children's work, pictures or whatever on a horizontal/vertical grid and not filling every available space, floor to ceiling;
- carefully selecting items placed on windowsills, cupboard tops or shelves and giving them adequate light and space.

Of course there will always be exceptions to any suggestions and these are made with the single view in mind of making classrooms easier to manage and attractive, pleasant places to be.

Display

Most classrooms have some spaces in which to mount displays of some kind. Flat, two-dimensional display is usually part of the wall surfaces, though, with care, the sides and backs of cupboards can sometimes be used and, exceptionally for particular reasons, windows. Windows have two surfaces, inside and out; where this is forgotten a window display can too easily become a cluttered mess, especially if it is left *in situ* too long.

A number of purposes for display can be distinguished:

1. To set up objects, create environments and provide visual and written information in order to stimulate ideas and responses. Such displays need to be clear in their purpose and care should be taken in how they are elaborated. Sometimes parts of rooms, corridors or corners can be given over to environments/displays for special occasions or to provide specific starting points for work, particularly in the area of feeling and response: these might include sounds, music, scents, foodstuffs, fabrics, objects and so on. Examples would be a stable or tent for Christmas in which children can sit, to capture certain aspects of the Christmas story to excite conversation, listening, participation and personal responses. Another example would be an island environment to stimulate experiment and invention in thought and making, with reflection on the needs and skills of others in past times or different cultures.

2. To enhance a particular piece of teaching and promote detailed enquiry, speculation or research. For example, placing transparent objects on a window ledge to promote observations and questioning about light: these could include glass objects, bottles, cut glass and prisms, mirrors and so on. Responses could range from science to language and be focused on particular subjects. Another example might be an object from the past or another culture, borrowed from a museum or personal collection, carefully displayed to give the possibility of all-round viewing and touching. Discussion about its purpose, context, the materials from which it is made and the way it is decorated can initiate learning in different curriculum areas.

3. To show children's completed work or work in process. Sometimes it is valuable to have a small pinboard space to display work in progress or experiments so that observations and comments can be made about them collectively and in exchange with a particular group or the whole class.

 Completed pieces of work (mounted on black, white or grey paper for ease and simplicity, so as to separate them from their surroundings) can be a source of personal pleasure, collective

enjoyment, and a stimulus for learning and further work.

4. To create an exhibition. Often it is necessary to think of some of the pupils' finished work being used in more public spaces in the school or beyond the classroom. It makes sense for teachers to keep examples of pupils' work ready mounted, singly or in groups, on one large sheet of paper. These could be stored in a deep drawer, shelf or box elsewhere than in the classroom, available for general display. In discussion, the class may decide which pieces should be treated like this as well as their teacher making a selection.

THE MOUNTING AND DISPLAY OF CHILDREN'S WORK

Why should children's work be mounted and displayed?

There are many points which could be made in answer to this question, such as the need to isolate and re-present pupils' work so that it can be seen to best advantage or to give pleasure and satisfaction to the maker and others. However, without reciting all such reasons, I will state one which is clearly educational and supports the teacher in the work he or she is doing.

It must be assumed that the teacher intended the pupils to experience something particular and learn from it. What might that be? Even though the purposes of the teacher will have been explained to the pupils, the level of understanding and skill with which they carry out the work will vary across the group. In considering the results of pupils' work, the teacher will see that many of them exemplify, in part, many of the aspects which he/she intended should be learned. Finding ways to discuss these results can highlight problems encountered, focus on what is learned and shape pupils' intelligence.

The natural consequence of this process (which reinforces the intended learning) is to isolate pieces of completed work from their surroundings and display them so that they can continue to exhibit the qualities and understanding the class had discussed. Examples of the different purposes and effects of display can be seen in the plates. To state it simply, effective display of children's work enhances and reinforces teaching and learning. This is especially so in a strongly visual subject like art, craft and design.

Mounting

Time for teachers is a precious commodity, made more scarce by the divisions of the school day: the more divisions the more time is lost in such activities as stopping, clearing away, moving about, getting ready for and attending to new directions. Yet, amongst all this movement of time, I believe it is essential, every so often, perhaps once a week, to 'timetable in' a space of time

when mounting work can be done. A well-mounted display makes an enormous impact, constantly reminding teacher and pupils of what has been achieved and what can be done, giving further ideas for development and just simple pleasure.

Mounting is necessary, but can be effected simply and surely, the simpler the better. Cutting round paintings (or any work children do) is totally unnecessary and unwarranted. Simple, right-angled rectangles and squares are sufficient. A pile of tidy work can be arranged on larger sheets of black, white, grey or brown paper and spaced out to a vertical/horizontal grid, keeping the outside edges level. A simple dab of paste (PVA) at each corner of separate pieces and replacing them on the arrangement will suffice. As each large sheet is stuck down the sheets can be piled up and pressed under a board or packet. They will soon dry and be flat and ready to display.

Other pieces of work will be worth mounting singly, but in the same manner, trimming the backing paper to fit the work and leaving a larger margin at the bottom. For exceptional pieces, perhaps for more general exhibition, double mounting is worth the extra effort, where grey, black, white or brown papers are used in combination and contrast. The first mount should leave a thin, even edge and then the whole be mounted again on a larger sheet with a wider margin at the bottom. This extra narrow edge can be of a colour other than neutral, which enhances the colours in the piece of work, but generally it is just as effective to keep to the simple, neutral range.

Gaudy, bright, fluorescent multi-coloured mounts should be strictly avoided as they destroy the subtleties and effect of the pupils' work and become a distraction from looking.

Small, experimental paint pieces can be mounted in collections on large sheets of paper: mounting on black will make them appear different from when they are mounted on white. The experiments will have been looked at, discussed and categorized into types by the teacher and the class; this will reveal how they can be grouped and displayed. These sheets of work are invaluable in registering where the class have reached in their handling and ideas about paint and can be referred to during the course of further painting sessions. For example, experiments in creating transparency can be looked at to recap on how this might be achieved.

Mounting and display has a powerful educational purpose and is an important tool in any teacher's repertoire.

Making stimulus/teaching collections

In my view, every school should bring together collections of various kinds as a source for display around the school, in classrooms and as a resource bank on which teachers can draw, just as they might use a library. What

might such collections include? The following gives a broad idea:

Two-dimensional materials like works of art (paintings, prints, drawings, fabrics, photographs); other kinds of photographic material, of locality, people, costume, transport and so on; pictures, posters, reference material and facsimiles; fabrics for display.

Three-dimensional materials/objects, made and natural, found and treasured; simple everyday things, past and present, particular toys, objects of historical or cultural interest from exotic and decorative ones to everyday, mechanical ones; items of dress and apparel, uniform or costume and so on. These may be from museums, personal collections, in the community or discovered in charity shops or on markets.

Then there are natural forms: wood, stones, bones, bark, sea flotsam and shells, stuffed animals and birds. The range is obviously enormous so, once again, it is important, once the collections are under way, to be rigorously selective, bearing in mind storage and special interest to particular teachers or aspects of school life or the community.

Many such items will wear out with use, others will have to be exchanged or replaced, but the notion of having a range of items, however small, to support teachers' work in class and displays around the school must be worth consideration.

It is perhaps still worth mentioning the special event or occasion, such as was witnessed when Victorian schools reached their centenary. On these occasions the whole community was drawn in to recall schooldays and times of a previous era. It amazed many to see how much material came from communities, not just objects but people and their reminiscences. Displays and re-enactments went hand in hand with visits, exhibitions and class work. These class or school events require careful planning as to the time of year and place in the school term. The follow-up in work across the curriculum must be thought through but any study of the National Curriculum in the core and foundation subjects will reveal many areas of teaching and learning which can grow from and be included in such a school event.

Many themes lend themselves to this whole-school approach, especially if they are clearly identified with the situation and community in which the school lives. For example the customs and culture of a particular group, their dress, food, religion and interests, sensitively handled with the right consultation, can yield riches in experience and resources for the curriculum.

Lastly, it must not be forgotten that looking at, discussing and enjoying the work of artists is an important and unique stimulus for painting. The visual and painterly ideas which come from this activity (whether it is sharing reproductions, originals or the practice and work of visiting artists) have a special value all of their own. The actual manner in which artists' sensibilities come together with the medium (paint) create a very special quality (which

could be called the aesthetic quality) distinct but not separate from the visual ideas which make up the painting. Children pick up these qualities readily, ask questions about them and want to try them out and learn from them.

The work of artists is obviously a source of enrichment to any painting programme and one which teachers can handle, as part of their own enjoyment and development of personal knowledge, with the pupils.

There are infinite possibilities for stimulating painting in all these things. The colours, textures, transparencies and richness of paint lend themselves well to recording and interpreting events, objects, people and places, especially if the classroom is right for painting.

CHAPTER 8
Assessment

When I think of assessment I picture a person making an effort to understand the approach and way of working of another and not only judging the result. Values and criteria have to be used, as in any form of evaluation, but the essence of assessment seems to be accepting the context and development of learning as well as the outcome.

When a person makes a judgement there seems to be a feeling of separation from the context and approach to consider only the result. Judging also has the mark of making comparisons with absolute values, of bringing informed opinion to bear, of pronouncement and award.

A dictionary definition (*Chambers Twentieth Century Dictionary*) distinguishes the two much along these lines:

to assess: to fix amount of (tax); to fix value of (profits); *to estimate*.
assessment: *a valuation*.
assessor: legal adviser; one appointed as an associate in office with another; one who sits beside; *one who shares another's position*; *one who shares another's dignity*.
to judge: to determine authoritatively; *to pronounce on*.
judgement: *the comparing of ideas to elicit truth*; *opinion formed*; discrimination; sentence, condemnation.
judge: a person appointed to decide in any contest, competition or dispute; one appointed to hear and settle causes; to try accused; one chosen to award prizes; *one who decides on the merit of anything*.

The aspects of the definition marked in italic bring out the differences between these two approaches as I see them working in education. Both have a place, with assessments being an integral part of the learning process and judgements the examination or testing of results.

In this chapter I am concerned to show how assessment, 'sharing another's dignity', leads to an increase in the learning and extension of the teaching which takes place and should be seen as an integral and natural part of teaching.

Reflections about how well children are learning are bound to arise during the process of teaching; thoughts will enter about how much they bring to the task and what they are able to understand of what is being taught; questions

will arise about the skills they are developing and their capacity to manage what they have to learn. Reflections like these may not be formulated clearly but exist in the feelings of satisfaction or frustration which all teachers experience. However one might describe such reflections, they are the material of assessment and the source of shared dignity with others' learning. Making assessments is something that everyone does as they teach.

Assessments are not as final or as formal as judgements; the latter are not mediated by experience but act as standards against which results are set. Assessments arise in the process of working and are used to tune into how learning is being managed and to shape and redirect the learning to desired ends. Judgements have a finality about them against which pupils' work is calculated; not, perhaps, a sentence, but of that flavour. Assessments seek the value of what is being done and reflect on or define the processes of learning as they take place.

Judgements tell us about the wider significance and relationship of what is achieved against universal standards (truths); assessments enable us to understand how learning is being achieved against values which are appropriate for the learner and criteria which can have a wider application.

The authors of the National Curriculum have seen assessment as both of these things: as formative and summative, and certainly wish assessment 'to enable pupils to understand the progress they are making' and teachers 'to see what stage of development . . . their pupils have reached' (DES, 1991, para. 8.5). It is in these respects that I wish to explore the function of assessment through the teaching of painting, trusting that those who read this chapter can use this approach as a reference for assessing children's art.

Assessing how pupils are learning, however this is done, acts as a personal feedback and regulating system through which teachers adjust and modify their approach. The level and pacing of the work to be learned is influenced by the responses of the children; sensitivity to the relationship between children and what they are asked to do is a major distinguishing feature of effective teaching. This quality is of prime importance in the teaching of art, where it is precisely the imaginative and personal responses of the children that are demanded by the work. The development of skills through practice and a knowledge of techniques are necessary to achievement but these alone, divorced from any personal response, are not enough.

We need, then, to look at these two aspects of assessment in more detail. First, the way in which assessment acts to develop art teaching and secondly, how assessment can raise children's levels of intelligence about art and art making. It is from consideration of these two aspects that an approach to written assessment will be suggested.

The development of art teaching through assessment

If we are in the role of teacher, it is assumed that we know, in ourselves, what we want our pupils to learn from us beyond the expectation that some art should be seen to be going on. Even if we have not thought about it as definitively as setting aims, this is what has to be done if teaching is to be coherent and have some direction. Writing down what we hope pupils will learn, however simply this is done, sets out and guides the work they undertake. A pattern of things to look for will develop within these aims, helping the teacher to assess changes in pupils' work and showing how they are achieving. As we shall see, this is a process that develops as the teacher works with pupils, both indicating the particular help pupils need to develop and how the teaching might be approached.

If we think pupils should have more than simply the opportunity to paint, and that they should also learn about paint and painting, then this aim poses a series of questions. Arising from their aims each person will find their own questions and ways of phrasing them; the examples given here are intended to indicate how this process develops and strengthens teaching.

An example of an aim might be that children should be able to paint with enjoyment, knowledge and confidence. Among the questions which this aim raises are: what should children know about painting? and what do I hope children will learn by handling paint?

Ideas about answers to these questions will form a basis from which to assess pupils' progress and determine results. Thinking about the answers to these questions will also guide discussion with pupils about their work, both identifying weaknesses and drawing out strengths.

I believe that however teaching is approached assessments are always being made and that it is difficult to make any useful assessments if teaching is conducted with no attempt to formulate aims and purposes.

If one believes that children should explore paint in order to learn how to handle it and know something of its characteristics, teachers need to find ways to build on children's experiences. To achieve this development, observations and conversations with pupils become an essential part of teaching. As pupils discover some of the characteristics of paint the teacher's observations will enable these to be described and understood more widely (see Chapter 2).

Plates 1, 2, 3 and 4 show the results of such painting sessions with infants and juniors, where the teacher's observation has led to an expansion in how children have used paint and an extension of their vocabulary to describe what they have found out.

Exploratory sessions need not be long, but as the teacher's confidence in children's developing knowledge grows and conversations about paint become routine and natural, questions can be explored which probe the

experience further and further and lead to more focused exploration and experiment. Questions like the following, treated experimentally by the children, can lead to a broadening of their experience:

How many different ways can you make marks with paint?
How have you mixed the paint for that particular set of marks? or even,
Can you tell us (i.e. the group or the class) about what to look for when exploring paint?

These kinds of questions become an essential part of teacher assessment to move the exploratory sessions forward and give them new directions.

The range of things that teachers will discover to share with children about their paintings will increase as their experience of managing exploratory sessions builds up. For example, an understanding of paint can include an awareness of its textures and surfaces, fluidity and transparency of colour, the effect of colour density and juxtaposition and so on. Teachers should be alerted to jot down their own 'awareness' schedule, while recognizing and enjoying children's conversations about these different qualities of paint, and develop this schedule as part of their assessment of children's learning.

Something that will be noticed is that many children will repeat things they have discovered and develop simple methods of mark making, mixing and applying paint, which begin to be their own. Repetition is satisfying and comes naturally, but also reveals how handling the medium takes on the form of a personal language, given the opportunity to do so over a period of time. This is parallel to mark making in graphic media (pencil, crayon, etc.). It is not just that these observations show us that we develop our own idiosyncratic way of handling materials but that we all have a need to do so. A pupil's particular way of managing paint should be noted in any assessment as it emerges and develops.

Teachers should realize that in these repeated and personal ways of handling paint, which are often independent from making pictures, children are developing their intelligence about painting and acquiring a feeling for its aesthetic rather than representational qualities.

The emergence of idiosyncratic, perhaps divergent, ways of handling paint can challenge a teacher's aims and raise questions about the direction and purpose of the teaching. For example, should divergence be heralded as a success of teaching or should it be redirected? In the first instance, it might vindicate an aim which celebrated individual creativity; in the second, it might indicate a lack of ability to make pictures. The way aims are formulated can change how children's work is viewed and the confidence with which a teacher responds to that work.

The short, exploratory (tuning in) experiences with paint can be linked to

handling paint for other reasons than those of discovering something about the nature of paint. It will be recognized that formless, directionless and continually random exploration with paints as a substance can soon lose its interest. This is why exploratory/discovery sessions should be short and the purpose of them become clearer as the teacher's experience increases. Linking these sessions to shared looking and discussion clarifies their purpose.

The reason for continually random exploration becoming dissatisfying is that the human mind likes to create order and form, to see shape and pattern in things and to name them; rather like seeing pictures in a fire or landscapes in the clouds. The imagination is as rich and varied in its capacity to make connections as it is precious. Teachers should not wish to predict what children may see through their anxiety for results but await with wonder revelations of the imagination. Teachers will be well rewarded by patience, for once children realize that it is acceptable to talk about and share what they feel inside, or see in their mind's eye, they will keep on doing so. Teachers who initially may feel they lack the confidence to handle such experiences will find that they have the skills to do so; these have been developed in areas of the curriculum with which they feel more confident.

It will be obvious to teachers that the selection of colours and paper surfaces to be used, type of implements (whether brushes of different shapes and sizes, sponges or rag, card or palette knives or whatever) and the way such sessions are introduced and arranged within the class or the group, are all important considerations that affect the outcome.

The increasing repertoire of skills and techniques that children discover for handling the medium can be assessed by the teacher because he/she has observed, noted and discussed these things with children as they paint. Furthermore, the vocabulary for conversing about paint and paintings develops as part of the interactive approach.

Conversations with the children about their painting will need to probe the purpose of exploration, the discoveries made and where they might lead. This probing will require other types of question which aim to deepen pupils' understanding of painting. For example:

> Which part of the painting do you enjoy most?
> What do you like about it particularly?
> Does that way of painting give you any ideas: how else might you see it?

The discussion might be extended to the immediate group of children who are painting, if they haven't already taken an interest, or even to the whole class.

> Can you see where someone else has painted like that?

Such questions function to refocus pupils' looking and open up other kinds of discussion than those related to simple mark making; an artist's work with similar qualities to those under discussion could be introduced to enrich and inform their looking further.

Questions which focus the looking and sharing on particular parts of a painting, when offered to other children in the group, generate more general conversation about what the painting might be. Teachers will find that, when they avoid making their own comments or putting ideas of their own forward, many ideas come from the children. Furthermore, teachers will find their own observational skills developing as they overcome their immediate preconceptions about painting and recognize a wider range of qualities in paint. Teachers and pupils will begin to make all kinds of connections with their own experience, which can be drawn into discussion of the painting children are doing.

Conversations with children about painting will reveal that the imagination is at work in responding to the medium, as much as the physical skills. If paint runs and smudges, physically this effect may be corrected or added to, but imaginatively it might suggest all sorts of possibilities from the extension of the colour range, through the newly found colours, to some fantastic picture or event which the paint suggests. Children will revel in the 'chance' behaviour of paint and the imaginative possibilities this offers, once they overcome the inhibitions that suppose painting is filling in neatly. If teachers have now included personal and idiosyncratic ways of handling and seeing paint in their aims, then these events can be taken in their stride. Here the starting point is *from within* the experience of paint itself but reaching imaginatively beyond it. This is an experience of painting which can be taken further and given a clear identity. The suggestions in Chapter 4 set out how this development arises.

Once children begin to talk about paintings, the questions, observations and shared experiences between teacher and children and amongst children will flow more and more naturally. Broader questions may emerge which reach beyond the act of painting, such as: Where have you seen colours like that? Which part of your looking makes you feel that way? Or they may be about methods and techniques: How did you put the paint on to get that effect?

ENCOURAGING CHILDREN TO LOOK MORE CLOSELY AT PAINTING

Various answers will be offered by the children as to what they enjoy about their work, where ideas come from, how mixtures of paint were made and so forth. Each observation or comment should be taken seriously even though some may appear, at first, to lack understanding of the task or to be fanciful

and impossible. Each child's observations about paint and painting should be related to specific examples drawn from the group's work. For example 'Paint is gritty' might be one child's discovery; the teacher could ask 'Who else has found gritty paint? What does it look like? Does it create special effects? Has anyone else made a gritty colour similar to this?' The child's piece of painting can be employed as a way of explaining another quality of the medium and extending the understanding of the group.

From answers and observations made by the children, together with their teacher, the paintings can be grouped and categorized by their different qualities, such as wet or thick paint surfaces, types and families of colours, pattern-like or random marks and shapes and so on. Teachers will soon see that children enjoy being involved in such a group exercise and that it sharpens their looking. As they build up confidence and experience of grouping paintings, further categories will be suggested with greater awareness and understanding of the potential and range of paint as a medium. Conversations about the effects, qualities and possible images produced in the paint will give the teacher lots of material on which to base assessments and from which to extend the teaching programme.

Another possibility that will enable children to understand the value of what they are doing is to share the paintings of artists with them. Children can be helped to see that a smudge or simple brush stroke can be an eye or a figure; that a collection of dabs can become a tree, or wet and smudgy paint, worked into with other colours, can suggest all manner of things. Painting can become an adventure in which paint itself is the guide but not the sole arbiter, for the imagination is a powerful ally and the support and experience of their teacher a safe anchorage from which to venture.

Children's growing confidence in how they see things for themselves and feel about their own ideas and decisions should also be noted in any assessment.

When children are well supported and can share what they do and the teacher sees problems and difficulties as significant points where learning can be maximized, they will find ways to resolve any problems they encounter. In fact children may be presented with specific problems to solve based on the teacher's assessment of the experience and understanding he/she has seen them acquire. An example can be seen in Plates 3 and 4, where children were challenged to mix 'cold' colours. Such a challenge should be in the context of children's experience and should grow from their looking and from conversations with them, and not be presented as an arid exercise.

Teachers will see that an understanding of paint which starts from just looking at what paint is like can soon develop into more sophisticated and personal discoveries. The evolution of skills and methods in handling paint, the care and discrimination in recognizing and describing changes in texture and colour, in themselves reveal how children have become more knowledgeable.

Teachers can assess these advances through the notes and observations they make about children's work and through keeping examples of individual's work as part of their records.

Looking carefully at the work of artists can provide a broader context for their discoveries. They can speculate about the reasons why artists use paint in special ways, how they have applied it and worked with it as they have. Teachers can encourage children to explore the images and surfaces of paintings to widen their understanding.

My argument is that the teaching of painting (and art) will develop through sharing children's discoveries and through noting the kinds of learning activity that go on. It is from the accumulated observations which teachers make of children learning that their understanding will be sharpened and they will see what to teach and what they hope children will learn.

A series of written comments and observations, derived from a teacher's work with children and informed by general aims, can be set down as markers or criteria with which to make assessments. Such criteria are necessary for some important reasons and every teacher should arrive at, or interpret personally, criteria for what he or she teaches.

Criterion 1. *Criteria establish a way of looking* at the work of a class or group of pupils that has the same basis for all.

The way of looking is not subject to likes and dislikes, alertness or forgetfulness, opinion or temperament. Neither do criteria depend largely on the attractiveness or otherwise of the work to that particular teacher. Criteria can cover a range of qualities and competences, some of which may note skills of accuracy while others note different qualities such as awareness of surfaces or strength of ideas.

Criterion 2. Having criteria from which to assess *avoids making judgements through comparisons* between children's work.

It is too easy to slip into making comparisons between one child's art and another's and this can lead many children to feel that they never succeed at painting (art) and will never be any good at it. Judgement through comparison is different from sharing the qualities and discoveries made by one child with others.

Criterion 3. Having criteria *enables every child to achieve* at some level and see what is required for him or her to do so.

Where teachers use criteria these can become an explicit part of the teaching with the children, helping them to see what is required and in what ways to develop. Using criteria enables teachers to work out avenues of development based on pupils' particular strengths and to identify weaknesses; in other words, criteria can be diagnostic as well as evaluative.

Criterion 4. Criteria *can focus understanding and observation* so that everyone's intelligence about paint and painting is increased.

The teacher may be aware of the subtleties of greens in a spring landscape and want to share this observation with the children. The teacher sees the mixing of many types of green as a problem for the children to overcome even if they had the same awareness of greenness. It is not until the children have engaged in experiments with yellows, blue, black and white that conversations about green become relevant and focused. Here an increased capacity to experiment with the mixing of colour was the criterion through which the observation and understanding of paint increased.

Assessment as a means for raising children's intelligence about painting

Changing, correcting and overworking paint enlarges children's competence and understanding of the medium. A teacher's support for children to handle paint in ways other than just filling in is vital, for this produces so much learning, although these activities can lead to frustrations. Once children are encouraged to see that many discoveries and satisfactions occur through overcoming difficulties, their painting will be extended considerably.

I will attempt to give an example of how these criteria might work and relate to a teacher's broad intentions in the hope that it will show how each person can arrive at criteria appropriate to his/her own teaching and in doing so improve children's painting.

AN EXAMPLE OF CRITERIA WORKING IN PRACTICE

A child may find difficulty in mixing colours together and both she and the group show through their comments and behaviour that they feel she is not good at painting. Yet her enjoyment of the texture of paint and the way it behaves is obvious and accords with the aim of teaching children to become familiar with the nature of paint as a medium. A comment or question from the teacher which acknowledges her response to paint as a substance establishes a starting point in her confidence from which she can be encouraged to explore colour mixtures. This avoids any comparisons that might have been made with the (apparent) success of the other children (criterion 2). Enjoying the textures and surfaces of paint she has made can also suggest other ways of looking at painting which may be new to her and to the group (criterion 1).

However, the need remains to enable her to mix colours with more success and a method must be devised to establish this piece of learning (criterion 3). To help her achieve some colour mixing the quantities as well as the range of colours she is to use are limited; the sizes of brush and paper likewise. Because of her observed enjoyment of paint texture, different surfaces of

paper and card, which have different absorbent properties (for example, sugar, brown and cartridge paper, brown and white reclaimed card) are offered and a variety of means for mixing are to hand (large and small brushes, strips of card or cane, sponge and rags, spatulas or palette knives). Access to fresh, clean water is assured and encouraged. Using just two colours and white, she is encouraged to experiment with ways of making new colours (criteria 1 and 2).

The teacher keeps her under observation so that, as soon as her attention wanes and/or she has worked on a few of the small pieces of paper and card, she is not left to flounder. It can also be seen that she has produced something that can be shared. All this may take just a few minutes, but its importance in bringing about a change in the child's understanding is considerable.

The teacher may now open conversations about her paint experiments by simple, open-ended questions. Can you tell me how you have made that colour? or, How did you paint this piece? and so on. What is so important is that the sharing is *on the basis of her discoveries*. The purpose of these exchanges, then, is to focus on the child's colour mixing and heighten her observation of what the paint has done and how it has been handled (criterion 4).

It would court disaster to leave her at this point to keep on covering small pieces of paper; the purpose of the experience would be lost as would the immediate response of the child to her discoveries. This sharing can proceed through comment and question and may draw in the other children in her group to focus on what has been done. The seriousness with which her paint pieces and discovered methods of mixing and applying paint are taken by the teacher changes the attitude of the group to her painting. They will all really look at her pieces and see what she has discovered; she will be the 'expert' in what has been done. The chances are that the other children will want to try out any new discoveries for themselves, and this should be encouraged. The group should not be left unobserved or for longer than the experiments take, and further conversations should ensue.

All the children will now have had their intelligence about paint increased in some way through such focused and controlled experience, devised to help one child give value to her painting but extended to the group (criterion 4).

These experiments can lead to wider looking, for example at objects or the environment.

The other children can see from this exchange with the teacher that there are many different things to notice about painting. As their looking and talking skills develop they could be given an added impetus by sharing the work of an artist. The children will now be able to explore an artist's painting from the angle of their new-found discoveries, both recognizing and conjecturing about how the artist has handled paint and also extending their own perceptions of painting.

The teacher will also learn about teaching painting through this experience, both in how specific criteria generate new ways of looking and how the teacher's repertoire of experiences to enlarge children's understanding can be increased. The new ideas which are evolved do not arise as a set of gimmicks or 'how-to-do-it' tricks but in answer to a real and perceived need in the developing understanding of the children.

At the end of such a session the teacher could lay out all the paintings that have been produced and look at them with the whole group or even with the class. A conversation about what has taken place, what individuals have discovered about paint or painting, about methods for mixing or applying paint and so forth, can be stimulated through sharing the work in this way.

The children can be asked to place the paintings into categories once they have started to distinguish different approaches, effects and ways of solving problems. These very categories can give the teacher a basis for talking about paint and painting with the children and be incorporated into the criteria used for teaching. While the children are looking at the collection of experiments produced by the group they will notice that some pieces remind them of objects, people, animals, places and so on. Pictures will seem to emerge from the surface of marks and colours; their imaginations will be excited by new possibilities.

PICTURES AND PAINT IMAGES

This observation introduces another aspect of painting which is very important, that of working from real or remembered experience. Children will readily see objects and people in their paint marks and attempt to depict them even though they are supposed to be exploring paint mixing and mark making. During the course of exploring what paint can do, arrangements of marks and shapes will emerge which might suggest other things. Some children will consciously arrange marks into patterns or find that they cannot just explore paint without painting a picture of something.

This extension of painting introduces two very important issues which, in my view, must be understood by teachers if they wish to advance children's understanding and practice of painting: both issues can be observed and verified by teachers when they are working with children.

First, handling and making experiments with paint (or any medium) potentially changes how the real world is seen. The things of the real world may dominate and circumscribe painted pictures as surely as an outline but the act of mixing and trying out colours, textures, shapes and surfaces with paint increases the perceptions of colour, texture, surface and so on in the world around. This is especially so if the teacher realizes the potential of a medium to do this, especially a medium as volatile and wide-ranging as paint.

This point has been made in Chapter 5. *Teachers help children to look every time they help them to handle the medium.*

Secondly, when one embarks on making a picture of something, however accurately it is depicted it remains a series of paint marks. In using paint to convey a response to an experience, the response shapes the paint, but as the painting proceeds the nature of the paint will change the form of the response. *The medium shapes the idea as much as the idea shapes the medium.*

The important discovery made here, which, with skill, teachers can exploit, is that paint creates images suggestive of real things, and real things, when painted, remain paint images. It is the coming together of the idea with the nature of the medium that creates the painting; it is not the filling in of a drawing or copy which does so. To repeat the maxim, the paint influences the idea as much as the idea shapes the handling of the paint. The notion was also explored when discussing the role of the teacher in Chapter 5.

Both these issues, when seen for themselves, significantly change how teachers will view and talk about children's painting and will help teachers avoid the trap which they and their pupils can fall into, of seeing painting only as representing accurately some aspect of the real world and filling in a drawing. We know that this trap is operating when children make comments like, 'I can't draw', 'I don't like paint, it's too messy' or become frustrated by trying to copy things with the medium which are beyond its capacity to represent within their present ability.

As teachers review the kinds of thing they have done or plan to do with their pupils, the purposes for teaching will become clearer and the tasks more finely tuned to developing children's understanding and skills. A number of criteria for assessing children's painting will suggest themselves as a result of this approach, while others on which the teacher has relied will be modified or abandoned.

Although there are now national criteria for assessing children's art, craft and design, it is still a necessary and valuable exercise for each teacher or group of teachers to interpret their teaching in terms of simple, manageable criteria. Such criteria will answer basic questions about a teacher's approach and the content of their teaching. For example, questions like, 'What am I looking for when I assess my pupils' painting (art)?' 'What can my pupils do and understand and what do they know?' promote reflection on what should be taught and question how it is learned.

A number of areas where criteria must exist will suggest themselves as teachers observe their pupils working and listen to them talking about the process and its results. Three areas have been identified by the National Curriculum Working Group (discussed in Chapter 6), but here I am concerned not to simply restate these areas but to suggest a way of seeking out criteria appropriate to one's own teaching. Looking and listening in order to come

across these personal, discovered criteria (to distinguish them from others) will clarify the areas in which teaching is needed. A number of areas of learning where criteria must exist suggest themselves:

1. *The handling and manipulation of media.* Not just the physical skill but also what has been learned and understood about the characteristics of paint and how these can be used through evolved and adapted techniques. Added to this must be the inventiveness which explores and uses a wide variety of paint properties, for example its transparency or opacity, relative colour strengths and so on. It seems obvious that painting is concerned centrally with the handling of paint. Therefore one looks for development in this area in the pieces children produce and the way they work at them. Are there mixed colours as well as pure ones? How have colours been mixed and put together? Is there evidence of care and discrimination in the way the paint has been applied?

2. *The response to paint and painting:* how it is enjoyed and the kinds of comment, reaction and observation that manifest this response. Observations and questions will also reveal something of the quality of pupils' responses and the level of their understanding, such as, 'Do you feel any of these colours as strong colours?' 'Why do you think the artist chose that colour?' or, 'Do you get any ideas from looking at that painting?'

3. *The capacity to use paint as an effective way to express ideas, observations and memories.* It is assumed that if children have ample opportunities to handle paint and to look at and discuss painting, they will become more knowledgeable and conversant with paint as a means of personal communication.

4. *The ability to develop ideas and interpretations through paint:* the ability, increasingly over a period of time and evident in a number of pieces of work, to see imaginative possibilities in paint and painterly possibilities in the real remembered world of objects, people, places and events.

Each of these four areas, or other or similar ones, could be arrived at through observation and listening by any teacher. They span a number of areas of activity from the obvious physical involvement with the medium and evidence in completed pieces of how this develops, to less overt responses and personal ideas and purposes.

Each of these states of learning and response to teaching may be picked up through observation and listening, but they also need to be confirmed through sensitive conversation, questioning and discussion. Sometimes this will be with individual pupils, but wherever possible and appropriate it should

take place with a group or the class. In this way discoveries and ideas are cross-fertilized and there is a chance that the whole class's intelligence about painting will benefit.

A range of questions and observations will occur within each of these areas which can then be used as the means for determining pupils' knowledge, understanding, progress and achievement in painting. It does not matter if a wide variety of observations and questions emerge over time as these can be honed and refined to a few essential criteria with which to make assessments.

It is from this interactive process that criteria for assessment will arise and can be formulated and set down in the teacher's own language. It is most likely that they will approximate to the criteria of the National Curriculum; nevertheless it is positively suggested here that the process of determining one's own stance on assessment criteria promotes a sense of confidence and personal control which is essential to effective teaching.

It may be helpful if I now take the process of identifying areas of learning further, showing how questions and observations might be turned into criteria (even if these have to be changed or modified in the light of experience). I recognize the dangers in making this attempt, because questions have to avoid interrogation and rhetoric; they have to be appropriate to the age and level of understanding of particular children and should not suggest stereotyped expectations of girls or boys. It would also be nice to think that an awareness of the cultural and ethnic context would be broader than West European. There is also the danger that the questions I pose will be adopted without further, relevant thought. These are chances I must take for the sake of clarity.

The comments, questions and observations of the teacher should grow naturally from a conversational, well-managed and sharing atmosphere, which is important for all learning, in my view, but particularly for learning which demands the creative participation of the learner.

It is also recognized that the personality of individual teachers does predominate and influences significantly how such matters as conversation, questioning and so on are handled. It is hoped that each person reading these suggestions will adapt them in their own way and find them, at least, a useful starting point.

SAMPLE QUESTIONS LEADING TO POSSIBLE CRITERIA FOR THE ASSESSMENT OF PAINTING (ART)

1. Handling and manipulation of media

How many ways have you found for mixing colours?
Can you tell me how you have made the paint do that?

Criteria. Pupils should be able to:

> mix and apply paint in a variety of ways;
> recognize some of the characteristics of paint.

2. *Response to paint and painting*

> How do you think this was painted?
> What do you notice about this painting?

Criteria. Pupils should be able to:

> notice different qualities of paint;
> respond to paintings with comments and ideas.

3. *The capacity to use paint as an effective way to express ideas, observations and memories*

> What did you notice about the object when you painted it?
> What did you like about the poem that you wanted to put into your painting?

Criteria. Pupils should be able to:

> invent ways in paint of interpreting what they see;
> capture something of the feeling or atmosphere of an experience in paint.

4. *The ability to develop ideas and interpretations in paint*

This criterion will probably be verified more through observation of a pupil's work over time than through conversation, because it is seeking to recognize a process of which the pupil may not be fully aware.

> Can you tell me where you found that idea?
> Is there part of the painting that made you handle the paint or look at the stimulus differently? Can you say how it happened?

Criteria. Pupils should be able to:

> develop ideas in paint from handling the medium and from looking at the sources of their ideas differently;
> change, reorder and transpose ideas and responses within the development of a painting.

Having arrived at these criteria, it is possible to use them as a guide to raise children's intelligence about paint and painting. Without such criteria,

developing children's intelligence must remain a hit-and-miss affair with the seemingly shifting opinions of the teacher as the only guide. Criteria can be understood by children when these develop as part of the learning experience; then children can appreciate the results of learning how to improve their handling of paint for its own sake, because this has been a declared purpose.

Similarly, children can begin to recognize heightened responses to painting and use a wider vocabulary to describe these. They will know when they feel more knowledgeable and confident in using paint to communicate and are able to devise new techniques for doing so. Perhaps most challenging of all, children will understand the need to interpret ideas and observations imaginatively in painterly terms as they develop the potential of paint to go beyond the representation and copy.

COMPILING AN ASSESSMENT SHEET

A number of words will stand out from any review of children's work and observational notes that have been made. These words will sum up the kinds of learning that have been taking place and can be used for a simple scale with which to identify progress. Both the words and how they are employed in the scale can be modified as experience develops. The following words emerge from the above example and can form the basis of an assessment scale.

> *confidence* – in any learning one would hope to see an increase in confidence;
> *skill* – with practice one would look for an increase in skill;
> *understanding* – if children are growing in intelligence about paint and painting, one would expect to see not only skill and knowledge about the materials and their use improving, but also a more general understanding in how children look at and speak about paint and painting.

This group of words can now be used to compile a scale:

Confident with skills and ideas, responds with understanding	(1)
Responds with skill and understanding	(2)
Shows understanding and commitment	(3)
Committed, but needs more practice and support	(4)
Needs support in basic experiences	(5)

As teachers become familiar with the use of their assessment scale, it will not only become second nature to them but also alert them to look for specific kinds of development.

These assessment descriptions can be shared with the children as part

of the process of helping them understand where and how to improve their work.

Figure 8.1 A possible assessment sheet card

Name of pupil description of work medium	1 confident with skills and ideas, responds with understanding	2 responds with skill and understanding	3 shows understanding and commitment	4 committed but needs more practice and support	5 needs support in basic experiences	

This type of sheet can contain an assessment of most of a pupil's work in art, craft and design along with examples of different pieces. It will become easier to use as familiarity with the descriptions develops. Perhaps more important than this, however, is that it will focus teachers' and pupils' attention on aspects of pupils' work that need support and extension.

Conclusion

Painting is one of the most enjoyable and expressive activities that teachers and parents can provide for children. I have attempted to convey some of the excitement and pleasure painting can give, but with an understanding of the medium and ideas about how it might be introduced and managed.

Powder paint is a deceptive and challenging medium and therefore all the more rewarding to master. It offers nothing if it is not handled properly in the way it is mixed and applied: there is much to be found out about it and its capacity to continue to excite, frustrate, satisfy and delight.

This book is about teaching painting and developing children's understanding and knowledge of paint and painting, from which skill and confidence grow. It is worth recalling some of the things that have been written about teaching art to children during the course of this century. From these we can reflect on present practices.

Paint, and frequently powder paint, is now found in every primary school and is usually available for children to use, but this wasn't always so. Initially, drawing was the main art activity, looked upon as a skill to be developed by copying under instruction and practised by routine. As Dick Field pointed out,

> The intention of the exercises set for children was at bottom to develop a skill. Courses of training were strictly practical, at first involving freehand drawing of straight lines of different lengths . . . later including the making of freehand copies, the notion being that the child in copying outlines of beautiful shapes would imbibe the principles of beauty. (Field, 1970, p. 6)

Eventually, when colour was introduced into children's art experience, it was taught by copying from the teacher's example.

At the same time as this formal training in art was the accepted method of teaching, a number of other teachers were responding to the ideas of philosophers and thinkers on human development and learning in Europe and Britain. As Field points out,

> In the revolution in attitudes towards children which occurred at about the turn of this century, art education had a part to play; and from that time on for almost a half century, art education could claim to be progressive and in the forefront of educational development, with its respect for the child and his work, its efforts to stimulate individual development, and the scope it gave for creative activity. (*ibid.*)

There were many who were beginning to delight in children's art as it was, attaching value to it for its own sake, amongst whom Marion Richardson was a significant pioneer. She described how she gave her pupils a word description, trusting in their capacity to 'image' it for themselves. The results surprised and delighted her. As her work with children developed she recognized that 'Even if the idea itself was artistically worthless, the efforts of expressing it were never so.'

She also realized that,

> In searching for the painted interpretation of the image the children explored to the utmost the technical resources of their materials, and gained experience which would stand them in good stead when a complete idea came along. (Richardson, 1948, p. 19)

In 1938 a vigorous debate developed following the publication of an article in *The Schoolmaster* entitled 'The new approach to art teaching: to be or not to be'. It was conducted in the columns of national periodicals. One respondent (Frank Hoyland) stated the changes in perception of children's art like this:

> there is something to be said for allowing the child to interpret the world of his experience in his own way, unhampered by the sophistication of the adult. To force him, therefore, as the object drawing lesson did, to accept an adult perception of objects which he is incapable of reconciling with his own, is unsound and simply teaches him to draw by rule of thumb. (quoted in Viola, 1944, p. 102)

For many years there have been debates not only about what children's art might be but especially about how much or how little adults should interfere with it by teaching! For example, in 1955 Ruth Mock wrote,

> In judging children's work, the criterion must never be how nearly can the child approximate to the adult, but always how true can he be to himself. Every child must use his own eyes if he is to learn to do anything worthwhile, and he must interpret what he sees through his materials in his own way. (Mock, 1955, p. 21)

At the end of the 1950s Her Majesty's Inspectorate published *Primary Education*, following in the tradition of the earlier *Handbook of Suggestions for Teachers*, but changed as a result of the 1944 Education Act (which created/ recognized primary schools as needing separate space and organization from secondary education). This book contained 'suggestions for the consideration of teachers and others concerned with the work of Primary Schools'. The authors addressed the contradictory issues of learning 'methodically' or learning 'through activity' and felt it was a pity that these two things had been misunderstood as being mutually exclusive. In relation to children's work in art and craft, the following passage, written in 1959, states the subtleties of the teacher's role clearly:

Drawing, painting and making things are for children a means by which they not only explore their world and learn, but through which they also express and sometimes communicate their emotions and ideas. . . . if children are to grow to the full they need to be helped specifically and consistently to use this native language that we call Art. The teacher needs to see that it is a fundamental basis for learning and maturing. Like all forms of language, its use involves effort: there must be respect for the materials employed if they are to be properly handled as instruments of ideas. Above all, children have to be helped to observe and see; and their school environment and their experience within it should together lead them to see with a growing acuteness and discernment, with finer appreciation and subtler feeling. *Children cannot be expected to grow in visual awareness unless they are taught*. Their nature is such that if they are merely surrounded by attractive materials and then 'allowed to develop on their own' they will fail to develop but rather repeat a performance ad nauseam and with diminishing effort and sincerity of feeling. Art and Craft are not mere recreation; they involve hard work and constant effort to master materials and techniques as they are appropriate to children's growing needs and powers. It must be recognised that laziness and slovenliness can mar what they paint or make no less than what they do in any other field; and a sense of progression is as necessary here as in every other aspect of education. (HMSO, 1959, pp. 220–1; emphasis added)

I quote this paragraph in full because it comments so directly and forcefully on the debate about teaching or not teaching in art. The often used dichotomy concerning approaches to teaching, between allowing children freedom to express their ideas and feelings or teaching them the techniques and disciplines to do so, can be seen to be false in the light of the above statement. The many teachers I have seen who have enabled and stimulated children to create with confidence and skill have continually sought and found the balance between positive teaching support and encouraging personal, creative expression which the above statement suggests and for which this book argues.

Seonaid Robertson believed in the need and power of children to make images from their deepest experiences and to develop a visual language to communicate these. She also recognized the difficulties teachers could get into if they allowed freedom of expression to be the sole *raison d'être* of their teaching in the hope that, thereby, children would find fulfilment:

This belief in the validity of children's art is reflected in the more informal atmosphere of their room . . . and the recognition of the personal nature of the art produced. Unfortunately, the essence of this freedom was too often misinterpreted by those who, without understanding the positive philosophy behind it, saw the 'new art' as a release from the former unsatisfactory position of trying to teach art as a technique. These [teachers], confused about the teacher's function, left the children to mess about in a vague self-expression without guidance in clarifying their ideas, or help in exploring their medium. (Robertson, 1963, p. xix)

125

In 1974 a Schools Council research and development project published the findings of three years' work looking at art and craft in primary and middle schools. Significantly, this was called *Children's Growth through Creative Experience* and focused the research on observing and listening to children as they worked, through making recordings using tapes, slides and notes. These were discussed with teachers as a way both of refining what was recorded and of developing teachers' thinking about their work. Amongst other things, the project team believed that 'Through the expression of their ideas and feelings, children grow inwardly, in personal awareness and sensitivity, and outwardly in confidence and in their capacity to communicate with others' (Schools Council, 1974, p. 19).

Understanding something about how children mature, for example in changes in perception and physical abilities, was considered necessary in order that teachers could make informed responses to children's work. This understanding went only some way to solving what the project saw as a dilemma for teaching.

> In art the freedom for children to do things in their own way has, for many years, been considered essential. There are, however, many teachers who feel that 'free expression' with a minimum of teaching leads to children experiencing difficulties in handling the materials and results in a loss of purpose and direction in what they do. (*ibid.*, p. 74)

It suggested that

> The teacher must have confidence to aim first and foremost to enrich the content and quality of children's experiences; central to this task is the teacher's sensitising children to the quality of materials that they use and the images and interpretations they create. His concern should be to value their capacity to think, to invent and to create with imagination and conviction at whatever level this takes place. (*ibid.*, p. 71)

The dilemmas of teaching were given a further penetrating dimension in the same year when *The Intelligence of Feeling* was published. In this book, Robert Witkin developed a series of ideas about art and intelligence, drawing on the notion of the inner world of feeling as distinct from the outer world of facts. The book explores thoroughly the creative act and places a central value for the arts teacher on understanding and handling children's expressive needs and powers: 'The arts teacher all too frequently finds himself vacillating between the extremes of facilitating and inhibiting self-expression' (Witkin, 1974, p. 169).

This issue – to teach or not to teach – is taken up again by Rod Taylor in *Educating for Art*:

> Because of their belief that one of the primary concerns of art education is to facilitate personal expression, relating to the child's inner world, but allied to an

equal conviction that the visual arts can and must be taught, many art and craft teachers find themselves having to attempt a precarious balancing act. (Taylor, 1986, p. 2)

Over recent years there has been considerable activity in thinking about the purposes and value of art in children's education. National associations, like the National Association for Education through Art and Design, the Association for Advisers in Art & Design and INSEA, the International Society for Education through Art, have all published material on various aspects of art education. Many local authorities have also published their own 'guidelines' for art education.

Furthermore, there has been an increasing exchange of ideas, views and practices about art education across the world, with conferences in many different countries, visits by art educators and the exchange of publications.

Amongst all this activity, advice and prescription there still remain the problems of what to teach, when to teach and at what stage to teach. So many writings on children's art, on the philosophy of art education and so on, never quite seem to meet this issue; it is left in abeyance for the individual teacher to work out in his or her own way. There are only the accumulated perceptions of those who have tried to write about children's learning and the mass of evidence about the changed content of what might or might not be part of the art curriculum.

The problem of how to develop the skills, sensitivity and understanding of children and young people through teaching art remains, but then perhaps it should. It cannot be for nothing that the issue of teaching in art has remained *sotto voce*, an undertone to all that is written.

I would conclude by expressing the belief that the problem of teaching or not teaching in art will not be solved easily, only, I suspect, by each teacher feeling and sensing his or her own way into the teacher–pupil relationships that enable solutions to this dilemma to be realized.

There is much help, advice and erudite description to hand and, as I hope I have shown, a long history of seeking to understand the processes of learning and what should be taught. What is sure is that the answers are not simple but, in seeking them, each person becomes a more sensitive and informed teacher and thereby more ready and able to educate children in art.

References

DES (1991) *Art for Ages 5 to 14*. London: HMSO.

Field, Dick (1970) *Change in Art Education*. London: Routledge & Kegan Paul.

Gentle, Keith (1985) *Children and Art Teaching*. London: Croom Helm.

HMSO (1959) *Primary Education*. London: HMSO.

Kellogg, Rhoda (1969) *Analyzing Children's Art*. Palo Alto, Calif.: Mayfield Publishing.

Mock, Ruth (1955) *Principles of Art Teaching*. London: University of London Press.

Richardson, Marion (1948) *Art and the Child*. London: University of London Press.

Robertson, Seonaid (1963) *Rose Garden and Labyrinth*. London: Routledge & Kegan Paul.

Schools Council (1974) *Children's Growth through Creative Experience*. Wokingham: Van Nostrand Reinhold.

Smyth, Peter S. (1936) *Art in the Primary School*. London: Sir Isaac Pitman & Son.

Taylor, Rod (1986) *Educating for Art*. Longman.

Viola, Wilhelm (1944) *Child Art*. London: University of London Press.

Witkin, Robert (1974) *The Intelligence of Feeling*. London: Heinemann Educational Books.

Index